IMAGES
of Modern America

STANDING ROCK
LAKOTA, DAKOTA, NAKOTA NATION

Donovin Arleigh Sprague and Rylan Sprague

ARCADIA
PUBLISHING

Published by Arcadia Publishing
Charleston, South Carolina

Printed in the United States of America

Library of Congress Control Number: 2015942097

For all general information, please contact Arcadia Publishing:
Telephone 843-853-2070
Fax 843-853-0044
E-mail sales@arcadiapublishing.com
For customer service and orders:
Toll-Free 1-888-313-2665

Visit us on the Internet at www.arcadiapublishing.com

Dedicated to the people connected to the Standing Rock Reservation.

CONTENTS

Acknowledgments 6

Introduction 7

1. Inyan Woslata 9

2. Oyate 41

3. Ateyapi Omniciye 81

Bibliography 93

Index 94

ACKNOWLEDGMENTS

Thanks go to the following individuals and organizations for their assistance in compiling this work: Dave Archambault II, Father Basil Atwell, Phil Baird, Russell and Cordelia Benoist, Earl Bullhead, Sam and Jace DeCory, Mary Louise Defender Wilson, Joe Flying By, Wilbur Flying By, Bill Gayton, David Gipp, Grand River Casino, Gladys Hawk, Mark Holman, Del Iron Cloud, Jean Katus, Tom Katus, George and Marilyn Keeps Eagle, KLND-FM, Kevin Locke, Dennis Neumann, Susan Kelly Power, Prairie Knights Casino, Mark Shillingstad, Charles Shoots the Enemy, Deb Sprague, Roger Sulcer, Jay Taken Alive, Jan Two Shields, United Tribes Technical Center, Frank White Bull, and the Sidney Whitesell family.

I want to especially thank Dennis J. Neumann of United Tribes Technical College for his interest in the tribal history and culture and for providing photographs and valuable information for the book. I also want to thank Mark Holman and KLND-FM for assistance. Finally, I want to thank coeditor Rylan Sprague and Deb Sprague for their assistance.

INTRODUCTION

The Standing Rock Reservation comprises 2.8 million acres and occupies territory in two states, North Dakota and South Dakota. Standing Rock was established as part of the Great Sioux Reservation. On April 29, 1868, the boundaries of the reservation were described under the Treaty of Fort Laramie. The Standing Rock Agency was later established in 1873. The Executive Order of March 16, 1875, extended the reservation's northern border to the Cannonball River. However, in 1889, Congress reduced the Great Sioux Reservation, dividing it into six separate reservations, including the Standing Rock Sioux Reservation. There were four million acres in the territory when it was established in 1864. It was greatly reduced in size following the Indian Wars of the 19th century.

The reservation now has a land base of 3,571.9 square miles (9,251.9 square kilometers) and a population of 8,250. The communities on the reservation are Fort Yates, McLaughlin, Cannonball, Bullhead, Kenel, Little Eagle, Porcupine, Solen, Wakpala, Selfridge, McIntosh, and Morristown. Some Standing Rock communities are no longer within the reservation boundaries, but they are included because they have enrolled tribal members living there. Many community schools may transport enrolled tribal members by bus from rural areas into their schools.

Generally, the word "Sioux" refers to the Lakota, Dakota, and Nakota. Most of the people who reside on Standing Rock Reservation today are Lakota and Dakota and speak the "L" and "D" language dialects. Most of the Lakota who were here when the reservation was established were the Hunkpapa Lakota and the Sihasapa Lakota. The Hunkpapa are more numerous; the Sihasapa (Blackfeet) were split up between the two bordering reservations of Standing Rock and Cheyenne River. When the boundary lines were established, most of the Sihasapa were among the Lakota at Cheyenne River. Many of the Dakota speakers are on the North Dakota side of Standing Rock Reservation.

Sitting Bull, a Hunkpapa Lakota, was a highly respected leader and medicine man who led the Lakota in the 19th century and is the best-known former resident of Standing Rock. Noted leaders during this era included Running Antelope, Pizi (Gall), Rain in the Face, Crow King, Grindstone, Crawler, Mad Bear, Long Soldier, Moving Robe Woman (Mary Crawler), John Grass, Josephine Waggoner, Two Bear, One Bull, White Bull, Red Fish, Flying By, and many others. Many in this group went to Canada following the 1876 Battle of the Little Bighorn. In the 1880s, many surrendered from Canada and were placed with other tribal members residing at Standing Rock Agency. The Ghost Dance movement, the killing of Sitting Bull at Grand River, the Wounded Knee massacre, and Wild West shows were important historical events in the 1890s.

The Standing Rock Sioux Reservation operates under a constitution approved on April 24, 1959, by the tribal council under the auspices of the Indian Reorganization Act of 1934. The tribal council chairman and council members serve for a term of four years. Of the 14 additional council members, six can be residents of the reservation without regard to residence in any district or state. Each of the remaining council members must be a resident of the district from which they are elected. The tribe stands by its rights of self-governance as a sovereign nation, which includes a government-to-government stance with the states and federal government.

The Indian Reorganization Act of 1934 (IRA) created tribal constitutions and governments. Since then, most tribes have accepted this act and elected chairmen, presidents, principal chiefs, and executive directors as officers. Other elected offices include vice chairman, secretary, treasurer, and tribal councils. Standing Rock Reservation did not adopt the IRA in 1934. In the mid-1940s, the Standing Rock Nation operated under a tribal business council; it adopted a tribal constitution in 1959.

In 1946, an Indian Claims Commission was established by the US government, allowing tribes to file court claims against the United States for lands taken in violation of treaties, agreements, and amendments. At that time, the Lakota, Dakota, and Nakota filed a claim for the loss of the

Black Hills, a sacred homeland. In the 1950s, tribes could lose their federal recognition status or be terminated as a tribe, in which case the tribe might cease to exist according to government law. Relocating the displaced tribes moved large numbers of American Indian people from their reservations into urban centers, resulting in an increase in the number of American Indians enlisting for military service.

As an affirmation of the rights of American Indian people, the Indian Civil Rights Act was passed in 1968, four years after the Civil Rights Act that was aimed at other minorities. In 1972, the Indian Self-Determination and Education Assistance Act allowed states more sovereignty, and tribes could contract their services to the US government. Most of these contracts are in the areas stipulated from treaties made with the United States and include education, health, housing, food supplement, social services, and other needs. Many of the programs on the reservation today come from these contracts.

Sitting Bull College and United Tribes Technical College are two institutions that serve the communities of the Standing Rock Reservation. Sitting Bull College began in 1973 as Standing Rock Community College. Education and training is a key component for the youth and future of the Lakota, Dakota, and Nakota people. In a progressive move, United Tribes Educational Training Center began in 1969, before the 1972 educational program movement. It was put into service as a residential, postsecondary vocational/educational institution. In 1975, a name change created United Tribes Educational Technical Center to reflect curriculum changes to meet workforce training skills. In 1987, the name was changed to United Tribes Technical College (UTTC) when the academic year switched from quarters to semesters.

In 1978, the American Indian Religious Freedom Act and the Indian Child Welfare Act were passed. In 1988, the Indian Gaming Act was passed, allowing tribes to establish their own gambling facilities. Because of this, the Standing Rock Sioux Tribe can operate the Prairie Knights Casino at Fort Yates, North Dakota, and the Grand River Casino near Mobridge, South Dakota.

The tribe currently has an elected chairman, vice chairman, secretary, eight district representatives, and six at-large members. The present tribal administration consists of Dave Archambault II (chairman), Jesse B.J. McLaughlin (vice chairman), Adele White (secretary), Avis Little Eagle (at-large), Ron Brown Otter (at-large), Paul Archambault (at-large), Jesse Taken Alive (at-large) Randal White (at-large), and Phyllis Young (at-large). The district representatives include James D. Dunn, Long Soldier; Milton Brown Otter, Rock Creek; Joe White Mountain Jr., Bear Soldier; Robert Taken Alive, Little Eagle; Samuel B. Harrison, Porcupine; Frank White Bull, Kenel; Cody Two Bears, Cannonball; and Duane Claymore, Wakpala.

US president Barack Obama and First Lady Michelle Obama made a historic visit to the Standing Rock Reservation on June 13, 2014. President Obama met with American Indian children prior to the tribe's annual Flag Day Powwow at Cannonball, North Dakota. The administration announced plans to reform the Bureau of Indian Education to better educate residents and to increase tribal control of education. About 1,800 people attended the event.

Today, people affiliated with the Standing Rock Reservation may live on the reservation or anywhere else in the world. Those who have moved away may or may not have original family allotment land. There are now eight districts on Standing Rock: Long Soldier, Cannonball, Wakpala, Kenel, Little Eagle, Bear Soldier, Rock Creek, and Porcupine. Many of the Hunkpapa and Sihasapa live on the South Dakota side of Standing Rock; many Dakota groups live on the North Dakota side.

The Standing Rock Reservation is a Lakota, Yanktonai (Ihanktonwana), and Dakota Indian reservation in North Dakota and South Dakota. It is the sixth-largest reservation in land base in the United States. It comprises all of Sioux County, North Dakota, and all of Corson County, South Dakota. There are also small areas of land in northern Dewey and Ziebach Counties in South Dakota.

—Donovin Sprague
Cankahu Wankatuya (High Backbone/Hump)
May 2015

One

INYAN WOSLATA

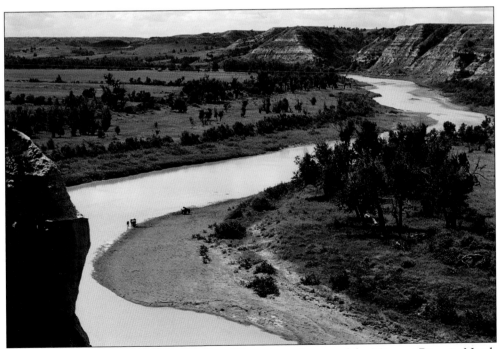

GRAND RIVER STANDING ROCK. The Grand River is a tributary of the Missouri River in North and South Dakota. The river passes through Standing Rock, where Sitting Bull was born in Dakota territory. (Courtesy of Dennis J. Neumann, *United Tribes News*.)

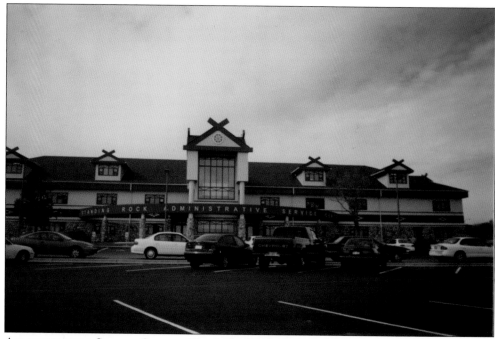

ADMINISTRATIVE SERVICE CENTER. This is the headquarters of the Standing Rock Sioux Tribe. Tribal government meets here. In addition, a number of tribal program offices are housed here. (Courtesy of Donovin Sprague.)

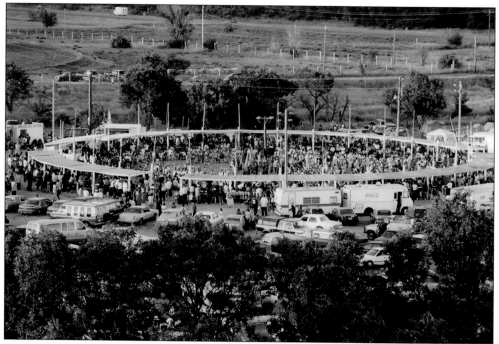

FORT YATES POWWOW. A large group has gathered for this Fort Yates powwow. It is held during the last week of July and into early August. (Courtesy of Dennis J. Neumann, *United Tribes News*.)

STANDING ROCK MONUMENT. This standing rock is mounted on a pedestal in front of the Standing Rock Reservation administrative offices. The Standing Rock Reservation takes its name from a natural stone formation that resembles a woman with a child on her back. Legend says that a Dakota woman became jealous of her husband's second wife, and refused to move with the tribe. When the man's brothers made their way back to bring her with the tribe, they found that she had turned to stone. (Courtesy of Donovin Sprague.)

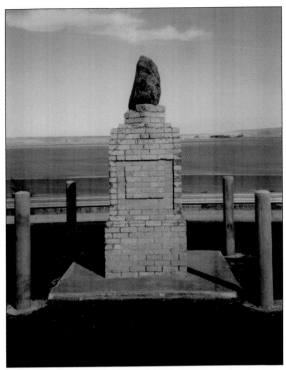

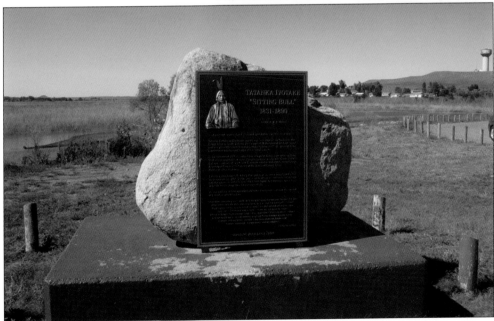

SITTING BULL GRAVESITE. This is designated as the gravesite of Sitting Bull, located at Fort Yates, North Dakota. Sitting Bull, a medicine man, retreated to Canada following the Battle of the Little Bighorn in 1876. He surrendered from Canada in 1881 and was placed at Fort Randall in present-day southern South Dakota. Later, he was moved back to join his people at the Standing Rock Reservation. He was killed on December 15, 1890. Some of his followers fled, and some ended up in the December 29, 1890, massacre at Wounded Knee. (Courtesy of Donovin Sprague.)

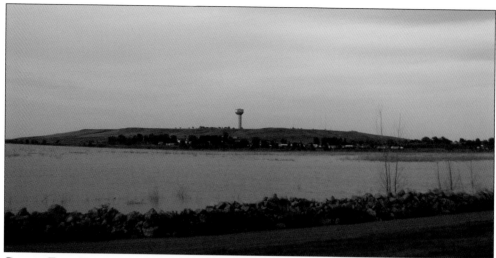

City of Fort Yates. Fort Yates is in Sioux County in North Dakota. In 1970, the population was 1,100, but this number had dwindled to 184 in a recent US census. Many people have moved into urban areas for employment opportunities or moved to the country. A US Army post was established here as the Standing Rock Cantonment, to oversee the Hunkpapa and Sihasapa (Blackfeet) bands and the Inhanktonwan and Cuthead of the Upper Yanktonai. In 1878, the Army renamed the fort to honor Capt. George Yates. When the fort closed, the city became primarily a Lakota-Dakota community. (Courtesy of Donovin Sprague.)

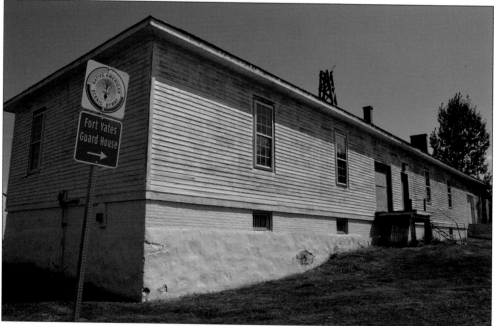

Fort Yates Guardhouse. Standing Rock Indian Agency moved from the Grand River to present-day Fort Yates in 1873 with only 12 soldiers. The post later grew to 3,000 troops. The original post included three sets of officers' quarters, a barracks, a guardhouse, two storehouses, a hospital, and other support buildings. The post closed in 1903 and became headquarters for the Standing Rock Reservation. Judges of the Indian Court at Fort Yates were Louis Gipp, Elk Nation, Francis Zahn, and Clement Cold Hand. (Courtesy of Dennis J. Neumann, *United Tribes News*.)

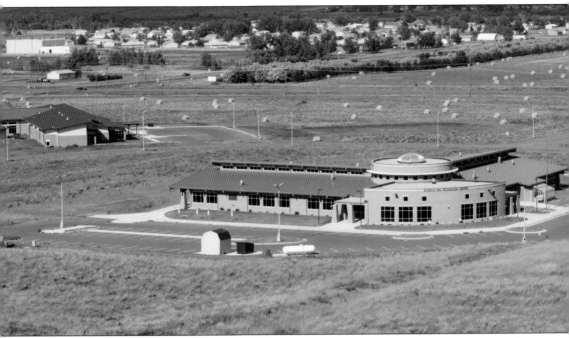

SITTING BULL COLLEGE. The main campus of Sitting Bull College is located at Fort Yates, North Dakota. It was chartered in 1973 by the Standing Rock Sioux Tribal Council as Standing Rock Community College and was renamed Sitting Bull College in 1996. (Courtesy of Dennis J. Neumann, *United Tribes News.*)

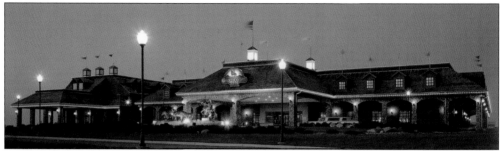

PRAIRIE KNIGHTS CASINO AND LODGE. This casino is located north of Fort Yates, North Dakota, on the scenic Standing Rock Reservation. It features the finest in gaming, dining, lodging, and entertainment. Fishing and boating on Lake Oahe are available at The Marina at Prairie Knights, which offers 24-hour security, boat ramps, slips, a fish cleaning station, RV sites and dump station, restrooms, and showers. (Courtesy of Prairie Knights Casino and Lodge.)

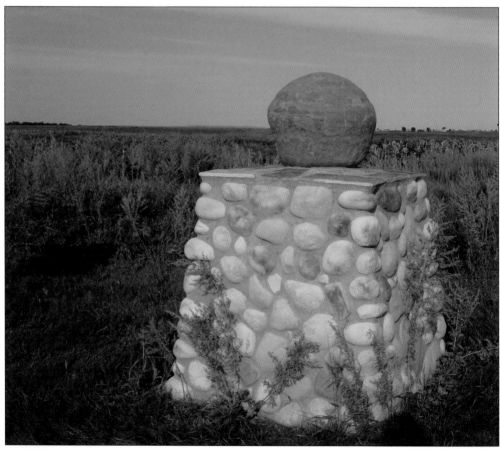

CANNONBALL MONUMENT. The community of Cannonball, North Dakota, gets its name from the unusual round boulder rocks that wash ashore from the nearby Missouri River. The rocks are shaped in the water. (Courtesy of Donovin Sprague.)

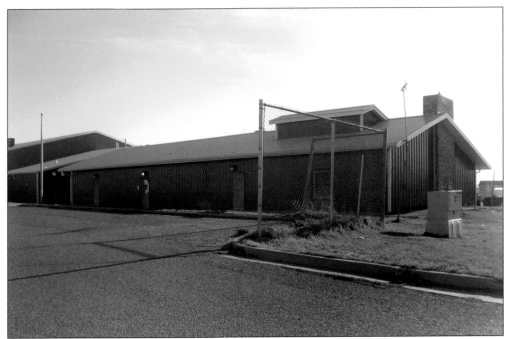

VETERANS MEMORIAL COMMUNITY BUILDING. This facility, in Cannonball, North Dakota, houses district offices, a US Post Office, and the Elderly Nutrition Center. Next door to the VM Building is the Community Center (Red Gym), where many community events and gatherings are held. (Courtesy of Donovin Sprague.)

CANNONBALL, NORTH DAKOTA. This photograph shows a housing area in Cannonball. In 1977, the *Cannon Ball Community Newsletter* was started, and in 1978, the *United Tribes News* appeared, with Harriet Skye as editor. (Courtesy of Donovin Sprague.)

TIPI WAKAN. This is the Tipi Wakan Baptist Church at Cannonball, North Dakota. The pastor is Buford "Boots" Marsh. This beautiful view is seen from the west side of the Missouri River. In very early times, it was reported that there was a church located south of Cannonball called White Lake Church. Memorial Congregational Church in Cannonball was served by such men as Oscar Good Boy, John Pretty Bear, Ramsey Bagola, Moses Flying By, Rev. Percy Tibbets, Rev. Douglas Widow, and Charles Shelltrack Sr. (Courtesy of Donovin Sprague.)

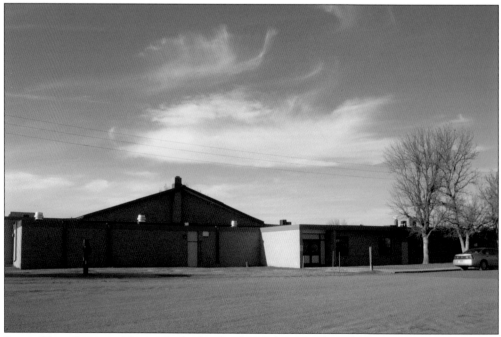

SOLEN HIGH SCHOOL. This is the high school at Solen, North Dakota. The school's mascot is the Sioux. Solen was founded in 1910 along a branch line of the Northern Pacific Railway that ran from Mandan to Mott. (Courtesy of Donovin Sprague.)

BASEBALL GAME AT SOLEN. Children and adults from the community participate in a game of baseball. The town of Solen is named for Mary Louise Van Solen, a French-Indian woman who lived at Cannonball when it was located north of the Cannonball River. The first school on Standing Rock was taught by Van Solen. She and her sister Lucille were buried on a high hill overlooking the Cannonball River. (Courtesy of Donovin Sprague.)

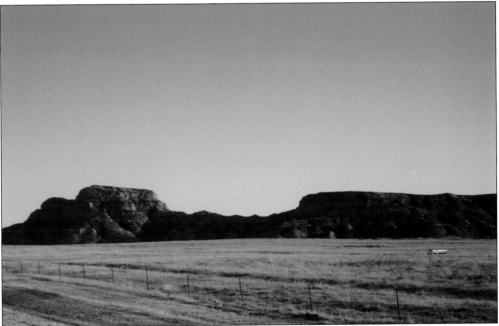

GIANT BITE HILL. This hill area, seen from the north, is near the Porcupine turnoff from the highway. It appears as though a giant bite was taken out of the geologic formation. (Courtesy of Donovin Sprague.)

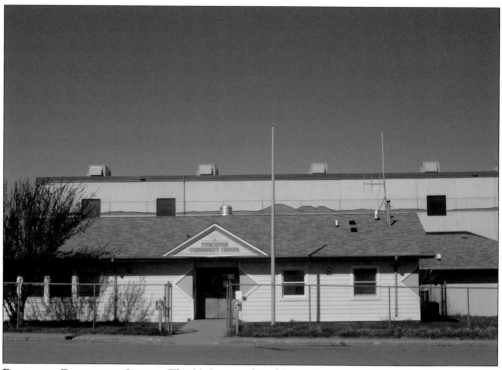

PORCUPINE COMMUNITY CENTER. The 2010 census listed Porcupine as an unincorporated community with a population of 146 people. Other nearby communities include Shields and Selfridge. (Courtesy of Donovin Sprague.)

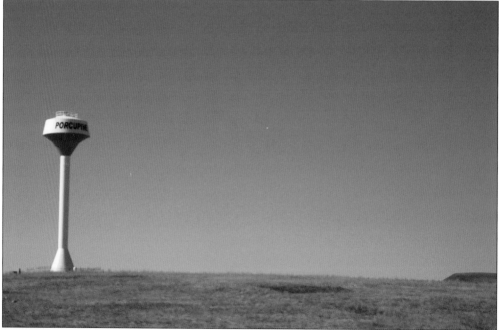

PORCUPINE WATER TOWER. This is the water tower at Porcupine, North Dakota, located east of town. (Courtesy of Donovin Sprague.)

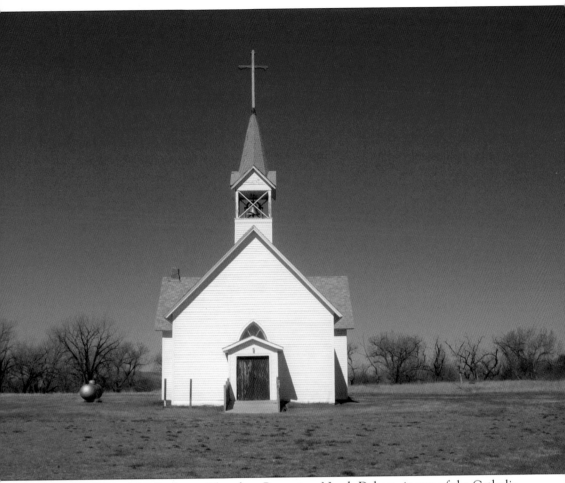

St. James Church. The St. James Church at Porcupine, North Dakota, is part of the Catholic Indian Mission and was established in 1886, four years before the death of Sitting Bull. The other locations are at Fort Yates and Cannonball. Pastor Basil Atwell conducts services at the church today. (Courtesy of Donovin Sprague.)

RESIDENTIAL AREA OF PORCUPINE. In 1909, J.W. Fletcher was the teacher in the government school at Porcupine. In 1910, Cecil Brown taught at the Porcupine Government School, which was attended by both Indian and non-Indian students. A new school was built in 1912. (Courtesy of Donovin Sprague.)

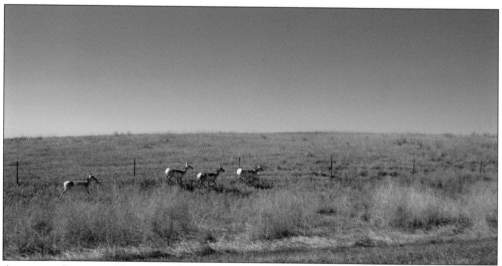

ANTELOPE COUNTRY. There is an abundance of antelope (pronghorn) throughout Standing Rock Reservation. The curious ones shown here are east of Porcupine, North Dakota. They can outrun a deer. These antelope demonstrated their preference for stepping through or going under a fence instead of jumping over it like a deer. (Courtesy of Donovin Sprague.)

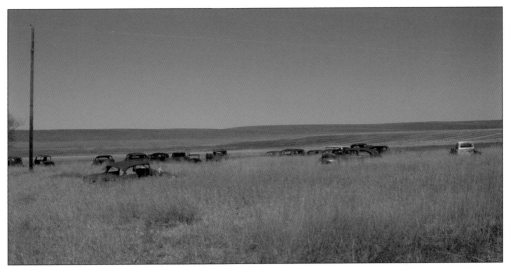

OLD CARS AT SHIELDS. Rusted-out cars are seen in Shields, North Dakota. The only business establishment in town is the Shields Bar. As early as 1910, the *Shields Enterprise* newspaper was being published. James McCormick was the editor and publisher. One of the first schools near Shields was in operation in 1907 in the sod home of Hannah Karlson on a bend of the Cannonball River. By 1910, there was a school established in a sod building south of Shields, with Nora Carter as the teacher. The basement of the Shields Congregational Church also served as a school. When the Shields school closed, children were bused to Flasher, North Dakota. (Courtesy of Donovin Sprague.)

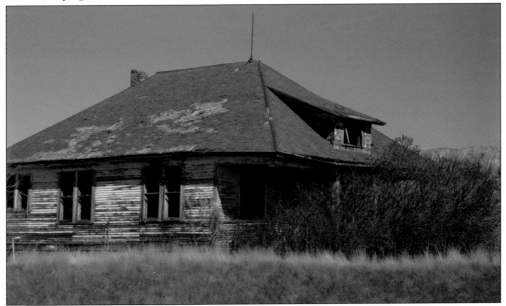

SHIELDS, NORTH DAKOTA. A fire burned out most of the town of Shields on July 1, 2002. This building stands just to the north of town. Only a broken foundation marks where a Lutheran church once stood in Shields in the early days. In 1917, pioneers built a church near Shields and named it St. Gabriel's Catholic Church. As people moved away, the church closed. In 1951, the church was moved to a new site and refurbished. It closed again in 1971 due to a lack of clergy. There was also the family-run Weinhandl Museum. (Courtesy of Donovin Sprague.)

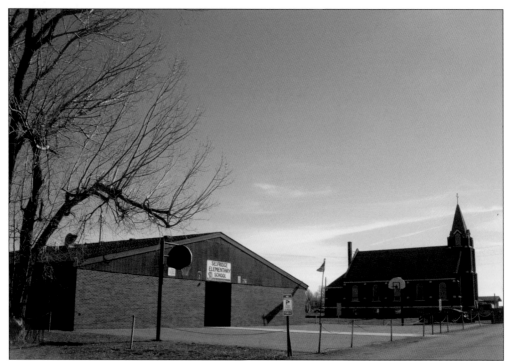

SELFRIDGE, NORTH DAKOTA. This is Selfridge Elementary School in Selfridge. The church is in the background. On July 1, 1918, the first volume of the *Selfridge Journal* was published, with James Fulton as editor. From 1921 to 1923, J.B. Smith edited this newspaper with assistance from Waldo Gayton. (Courtesy of Donovin Sprague.)

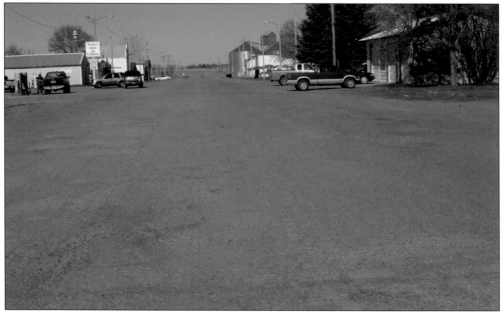

DOWNTOWN SELFRIDGE. In early times, some families owned huge tracts of land. Charles, Sam, James, John, and Joe Gayton once owned all the land around and including the site of Selfridge. By 1970, Selfridge had a population of 346. (Courtesy of Donovin Sprague.)

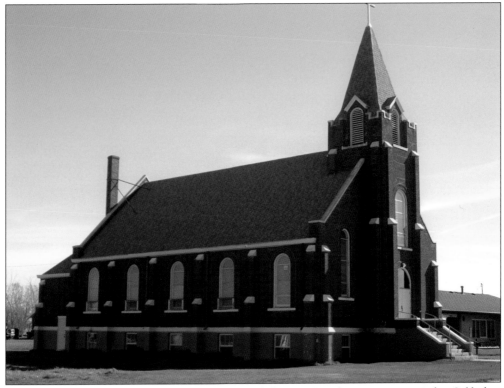

St. Philomena Catholic Church. In 1919, St. Philomena Parish was incorporated in Selfridge, North Dakota. A basement was constructed for a church in 1929, and, in 1931, the upper part of the church was added. The following year, the church was finished and dedicated. (Courtesy of Donovin Sprague.)

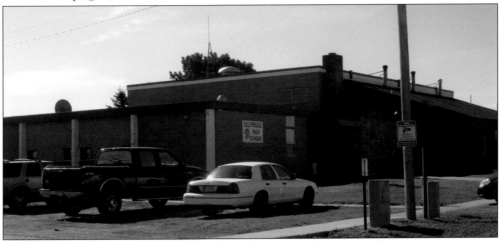

Selfridge High School. This school is the home of the Chieftains. There was a government Indian school northeast of Selfridge known as Schoolhouse Hill, called Twin Buttes by some. In 1965 St. Philomena School was discontinued, and students transferred to Selfridge Public School. In 1890, Selfridge was known as Goose Camp, named after Chief Joe Goose. In 1900, Goose Camp was designated as a station, a place where masses were held at regular times. (Courtesy of Donovin Sprague.)

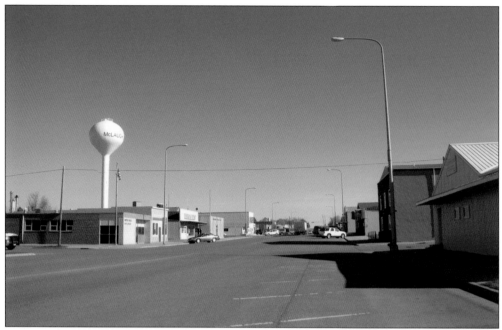

DOWNTOWN MCLAUGHLIN. This photograph of Main Street in downtown McLaughlin, South Dakota, looks to the north. The town is named for Standing Rock Indian agent Maj. James McLaughlin, who served for 52 years in the Bureau of Indian Affairs, one of the longest terms in federal history. The town is part of the Bear Soldier District on Standing Rock Reservation. (Courtesy of Donovin Sprague.)

VETERANS MEMORIAL PARK. The log cabin in which Sitting Bull lived and was killed was moved to this park in McLaughlin at one time. It was formerly on the Grand River at his home campsite. The log cabin was then moved to the Chicago World's Fair in 1893, where it was dismantled. It was never returned. (Courtesy of Donovin Sprague.)

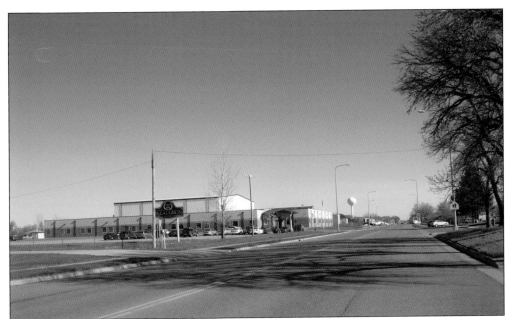

McLaughlin Public School. In this north-facing photograph, the McLaughlin Public School and gymnasium are on the left side of the street. The campus consists of an elementary, middle, and high school. The school recently held the 11th annual Wacipi (powwow) and Culture Day. McLaughlin, in Corson County, had a population of 663 in 2010. This is the largest city on the Standing Rock Reservation. (Courtesy of Donovin Sprague.)

Bear Soldier South Tribal Housing. This residential housing area is located just south of McLaughlin. (Courtesy of Donovin Sprague.)

McLAUGHLIN, SOUTH DAKOTA. This view is from the west side, coming into McLaughlin. The town is named after US Indian Service agent James McLaughlin, who supervised the Standing Rock Agency from 1881 to 1895. He moved to Washington, DC, and took the position as inspector of the Bureau of Indian Affairs and at the US Department of the Interior. He died in 1923, and his body was returned here for burial. (Courtesy of Donovin Sprague.)

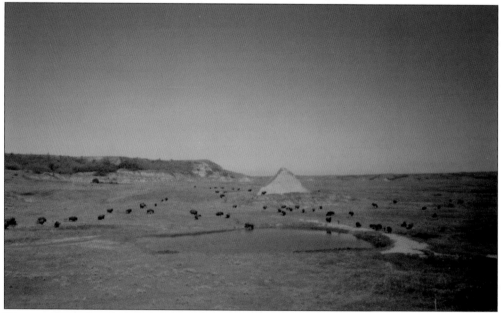

BUFFALO HERD. The buffalo has always been important to the tribal people. In the early days, the animal provided food, shelter, and clothing for everyone. The hides were tanned and processed into pure rawhide leather and buckskin. Every portion of the buffalo was used. Its meat is lean. Shown here is one of the buffalo herds at Standing Rock. Some ranchers are now raising buffalo. (Courtesy of Donovin Sprague.)

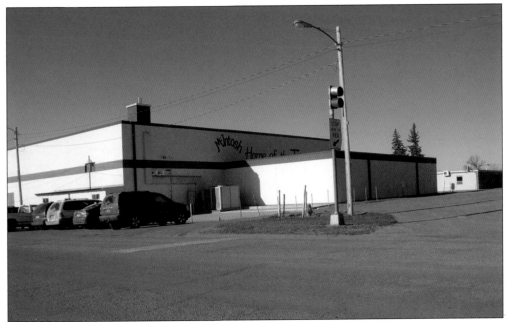

McIntosh High School. This is the McIntosh High School, home of the Tigers. McIntosh is the county seat of Corson County in South Dakota. The population of the town was listed as 176 in 2013. (Courtesy of Donovin Sprague.)

KLND-FM Radio. This noncommercial radio station is located between McLaughlin and Little Eagle, South Dakota, five miles south of McLaughlin. It serves the Standing Rock Reservation, the Cheyenne River Reservation, and surrounding area at 89.5 on the FM dial. The station's Lakota name, Wolakota Wiconi Waste, means "through unity a good life." It features a variety of news, public affairs, music, and cultural programming. (Courtesy of Donovin Sprague.)

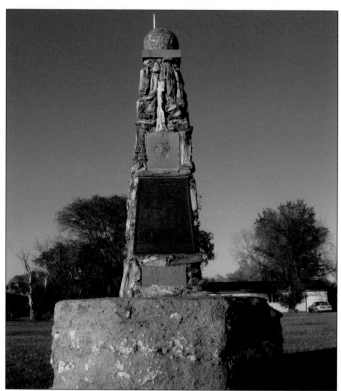

US VETERANS MONUMENT. This monument at Little Eagle was dedicated on July 28, 1934. It is a tribute to Standing Rock veterans who served in World War II and to past warriors. Half of American Indians are veterans of US wars, the highest rate of military participation by any ethnic group in America. This monument, in memory of Hunkpapa chiefs, lists the following names: Sitting Bull, Running Antelope, John Grass, Gall, Rain in the Face, Crow King, Fire Heart, Flying By, Mad Bear, and Grindstone. Sitting Bull School is also located in Little Eagle, serving students from kindergarten through eighth grade. (Courtesy of Donovin Sprague.)

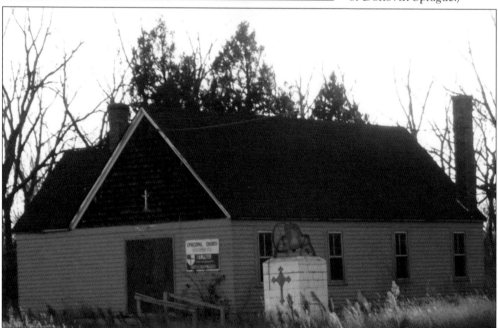

ST. PAUL EPISCOPAL CHURCH. This is the Episcopal church at Little Eagle, South Dakota. The area was earlier known as Running Antelope, named after an important Hunkpapa leader. The village was later named for Little Eagle, an Indian policeman who lived after 1890. Little Eagle, in Corson County, had a population of 319 in 2010. (Courtesy of Donovin Sprague.)

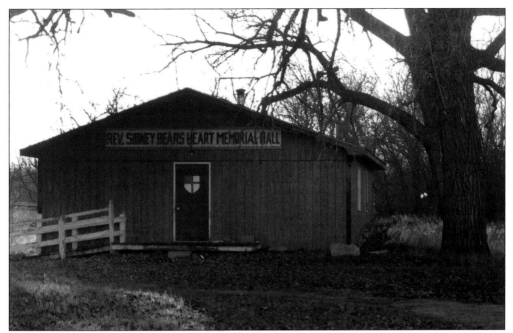

REV. SIDNEY BEARS HEART MEMORIAL HALL. This is a community center at Little Eagle named for Rev. Bears Heart, who was from Wakpala. His son Wilbur is also a priest. The leader Running Antelope is buried east of here in the Long Hill Cemetery. (Courtesy of Donovin Sprague.)

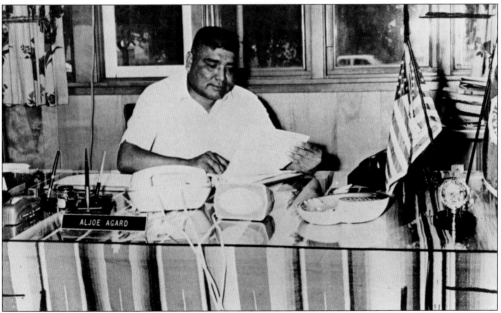

ALJOE AGARD. Alfred Joseph Agard was born at Black Horse, South Dakota, in 1928 to James and Isabelle (Shoestring) Agard. His grandfather was Moses Old Bull. Agard served as chairman of Standing Rock from 1961 to 1969 and was a veteran. He was cofounder of United Sioux Tribes of South Dakota and active in the National Congress of American Indians. Agard served in tribal leadership for 40 years and was part of the Standing Rock Tribal Council until his death in 1993. (Courtesy of Dennis J. Neumann, *United Tribes News.*)

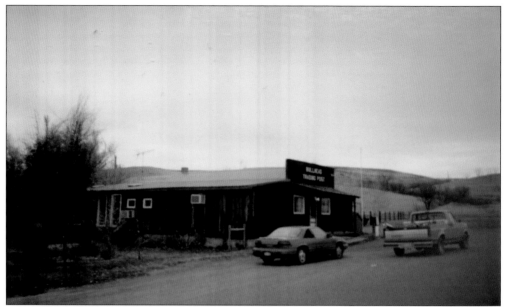

BULLHEAD TRADING POST. This trading post at Bullhead, South Dakota, is pictured in 2003. The area of Bullhead is known as Rock Creek District on the Standing Rock Reservation, one of eight districts on the reservation. It is in Corson County. The 2010 population was 348 people. An annual powwow takes place just north of this store. (Courtesy of Donovin Sprague.)

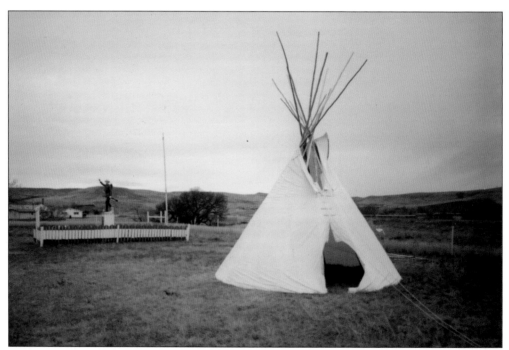

DOUGHBOY STATUE. The statue *Spirit of the American Doughboy*, seen on the left, was erected on June 28, 1935, at Bullhead to honor the Americans who served in World War I. (Courtesy of Donovin Sprague.)

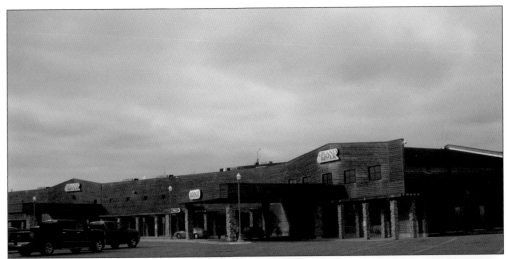

GRAND RIVER CASINO. The Grand River Casino opened in March 1994. One of two large casinos on the Standing Rock Reservation, it is located four miles west of Mobridge. The casino overlooks the Missouri River, which provides recreation for fishing, hunting, swimming, and boating. (Courtesy of Donovin Sprague.)

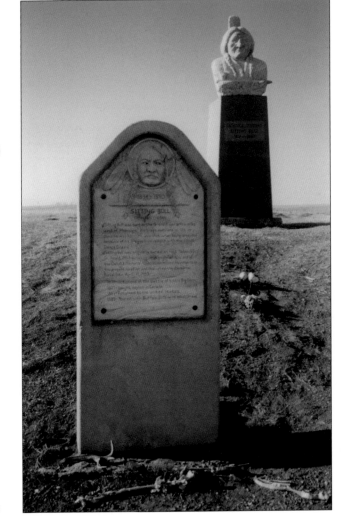

SITTING BULL MONUMENTS. These monuments stand near Mobridge. The body of Sitting Bull was supposedly removed from his first burial area at Fort Yates, North Dakota, to this location in South Dakota in 1953. Remains were removed, but there is debate whether the remains were of Sitting Bull or of someone else. (Courtesy of Dennis J. Neumann, *United Tribes News*.)

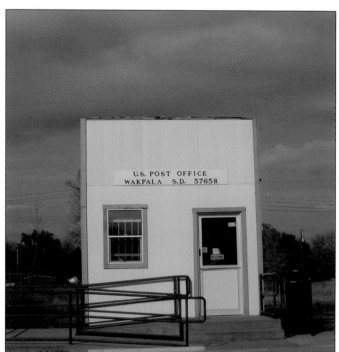

US Post Office, Wakpala. The post office serves the small community of Wakpala, an unincorporated community in Corson County, South Dakota. The population was 200 in 2000. The annual Wakpala Wacipi (powwow) is usually held on a weekend at the end of August. The Hunkpapa leader Pizi (Gall) is buried near this community. (Courtesy of Donovin Sprague.)

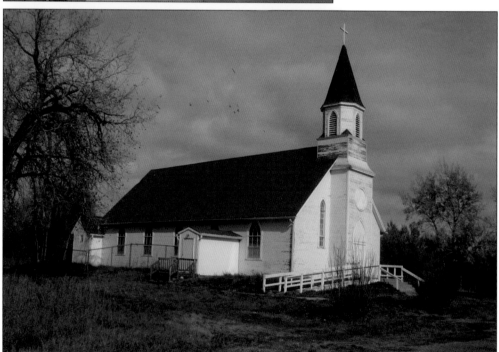

Church of St. Bede. This church in Wakpala is named after a saint of the Benedictine Order. A small creek divides the church from its cemetery. Some years ago, a rush of flood water washed out the bridge and it was never rebuilt. Today, parishioners must travel many miles out of their way to get to the burial place that was once just a stone's throw from the church. (Courtesy of Donovin Sprague.)

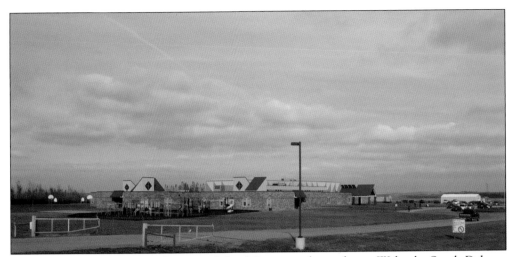

WAKPALA PUBLIC SCHOOL. The Smee School District is located near Wakpala, South Dakota, on the Standing Rock Reservation. The Wakpala Public School and community are next to the Missouri River. (Courtesy of Donovin Sprague.)

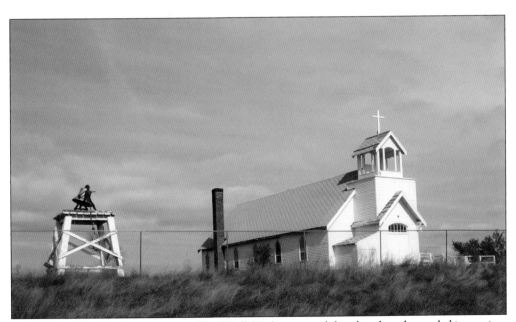

ST. ELIZABETH'S EPISCOPAL CHURCH. Chief Gall (Pizi) supported this church and attended its services about 150 years ago. He is buried in the Episcopal Cemetery behind the church. St. Elizabeth's Episcopal Church is located on a hill just east of Wakpala, above the Missouri River. It was also the location of St. Elizabeth's School for over 50 years. (Courtesy of Donovin Sprague.)

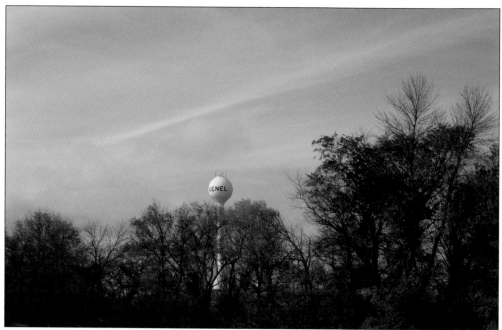

KENEL WATER TOWER. The community of Kenel, located in Corson County, overlooks the Missouri River. Kenel, near Mobridge and Wakpala, has excellent fishing and boating access. The community is named for Father Kenel. (Courtesy of Donovin Sprague.)

KENEL, SOUTH DAKOTA. This is part of the residential area of Kenel, next to the Missouri River. Fort Manuel is located near Kenel, and the town has monuments for Father Martin Kenel and Father Bede Marty. (Courtesy of Donovin Sprague.)

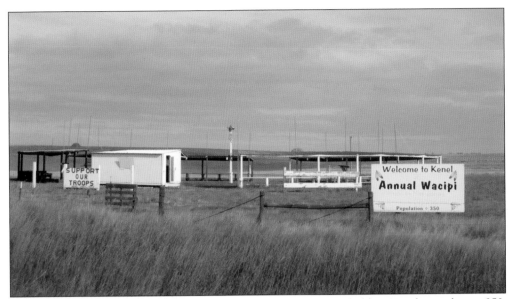

KENEL POWWOW GROUNDS. This is where the annual Wacipi is held at Kenel, population 350. During the summer, visitors can find a powwow celebration about each week at one of the communities on Standing Rock. (Courtesy of Donovin Sprague.)

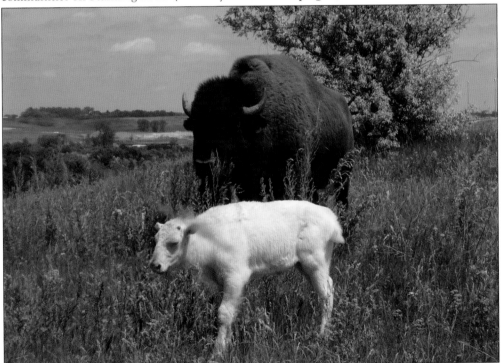

SACRED WHITE BUFFALO CALF. Seen here with an adult buffalo is a rare albino buffalo calf. White buffalo were always revered by the tribe. The white buffalo calf is also associated with the White Buffalo Calf Woman and the White Buffalo Calf Pipe in Lakota Dakota Nakota society. Stories have been told for many generations about this woman, who came and brought with her the pipe that was given to the people. (Courtesy of Dennis J. Neumann, *United Tribes News.*)

HILL AT STANDING ROCK. This hill resembles a man lying on his back, looking up at the sky. This area is north of the Cannonball River, on the road between Cannonball and Mandan, North Dakota. (Courtesy of Donovin Sprague.)

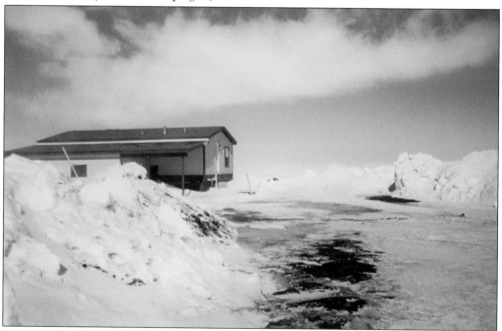

SNOW AT STANDING ROCK. This 1997 winter storm dumped much snow in the Standing Rock area. The photograph was taken at KLND-FM's building. The radio station is an important link for the people, providing news updates and other programming. (Courtesy of Dennis J. Neumann, *United Tribes News.*)

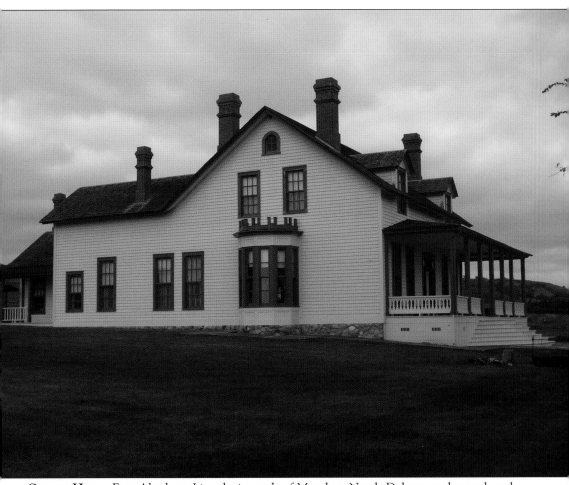

CUSTER HOME. Fort Abraham Lincoln is south of Mandan, North Dakota, and served as the home base for Lt. Col. George A. Custer and his 7th US Cavalry command. From the fort, they undertook two historic expeditions: the 1874 Black Hills Expedition, and the 1876 Battle of the Rosebud and Battle of the Little Bighorn. (Courtesy of Donovin Sprague.)

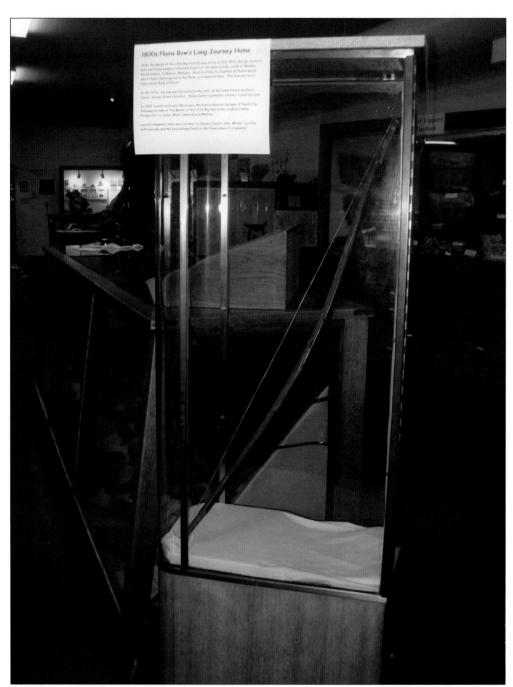

NORTHERN PLAINS INDIAN BOW. This bow was presented to the author in 2009 by descendants of the Custer families at Monroe, Michigan. Loretta and Laura Weiss were the modern caretakers of the bow. Loretta's husband, John, was the brother of Charles Custer's wife, Minnie. The bow was transported to Monroe from Fort Abraham Lincoln following the 1876 Battle of the Little Bighorn. It was found in this area of the plains, and its original owner is unknown. The bow is on loan display at the Timber Lake & Area Museum in Timber Lake, South Dakota. (Courtesy of Donovin Sprague.)

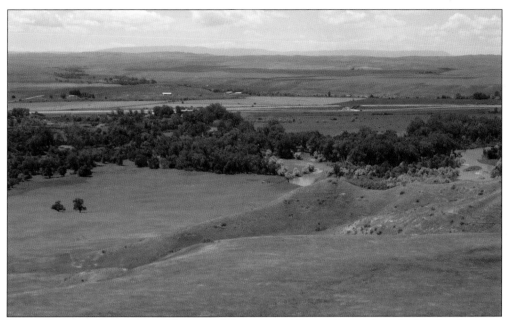

LITTLE BIGHORN BATTLEFIELD NATIONAL MONUMENT. This is the south end of the battle site in Crow Agency, Montana, where the Hunkpapa Lakota were first attacked by Maj. Marcus Reno of the 7th Cavalry. The valley bottomland is where the attack was made. The Hunkpapa and others soon forced the soldiers to retreat back across the river and up the steep hillside, where they dug in to defend a hilltop position. (Courtesy of Donovin Sprague.)

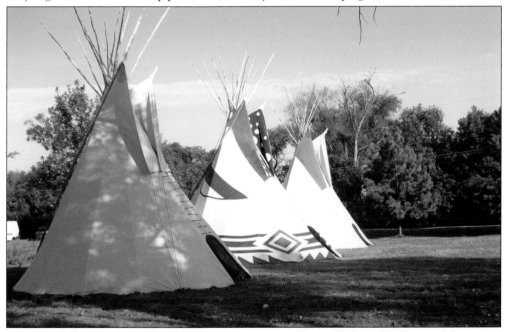

TIPIS AT UNITED TRIBES INTERNATIONAL POWWOW. United Tribes Technical College and the annual powwow is in the city of Bismarck, about an hour away from the Standing Rock Reservation. Bismarck, the capital of North Dakota, is the state's second-largest city. Many urban Lakota, Dakota, and other area tribes reside there. (Courtesy of Donovin Sprague.)

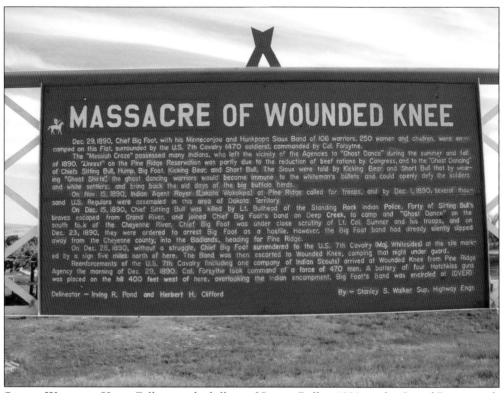

SITE OF WOUNDED KNEE. Following the killing of Sitting Bull in 1890 on the Grand River, south of Bullhead in South Dakota, his followers journeyed to the Ghost Dance camps of Hump and Spotted Elk (Big Foot) at Cheyenne River, South Dakota. From there, Spotted Elk led many people of the Minnicoujou and some Hunkpapa and Itazipco Lakota to the Pine Ridge Reservation in South Dakota, where many were killed in the December 29, 1890, Wounded Knee massacre. This sign is at the massacre site. (Courtesy of Donovin Sprague.)

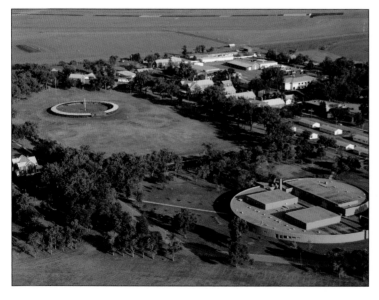

UNITED TRIBES TECHNICAL COLLEGE. This aerial photograph shows the United Tribes campus and historic buildings. The central parade ground (center) is where the powwow is held. (Courtesy of Dennis J. Neumann, *United Tribes News*.)

Two

OYATE

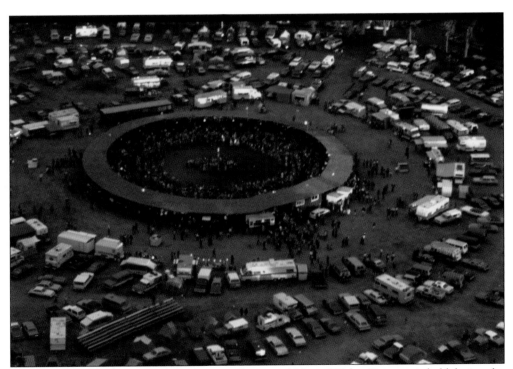

UNITED TRIBES INTERNATIONAL POWWOW. The annual United Tribes Powwow is held during the Labor Day holiday in September in Bismarck. At this time, tribes from across the United States and Canada gather to celebrate and dance. Many vendors set up their wares, and camping is available. A Miss Indian World is also selected and crowned at this time. (Courtesy of Dennis J. Neumann, *United Tribes News.*)

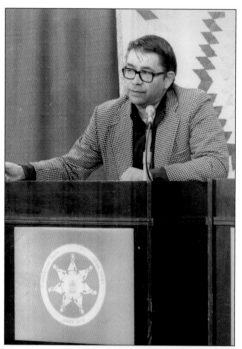

VINE DELORIA JR. This noted educator and author gives a presentation at Standing Rock. He was the author of many books on American Indian policy and history, including *Custer Died for Your Sins, Behind the Trail of Broken Treaties,* and *God is Red.* His grandfather Phillip Deloria was a priest at Episcopal church in Wakpala. (Courtesy of Donovin Sprague.)

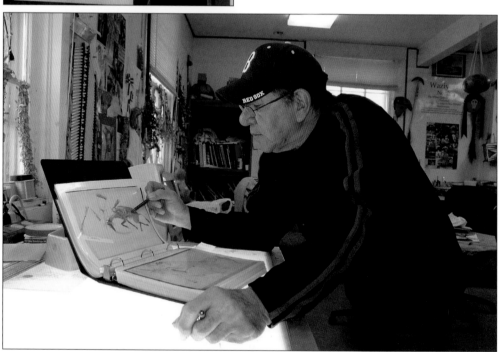

WALLACE "BUTCH" THUNDERHAWK JR. Butch Thunderhawk is shown in the United Tribes art gallery. After high school, he graduated from Dickinson State College in North Dakota. He studied graphic design at the College of Arts and Crafts in Oakland, California. As an arts instructor at United Tribes, he is in his 43rd year of teaching. He has created works for the James Monroe Museum in Charlottesville, Virginia, and the Thomas Jefferson House Foundation. (Courtesy of Dennis J. Neumann, *United Tribes News.*)

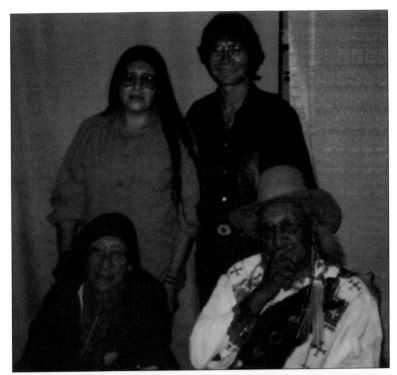

DENVER, FOOLS CROW, AND DECORY. The singer (standing at right) was popular not only for his folk music, but also as an activist working to protect the land. In this photograph from the 1980s, Denver is standing at right next to Jace DeCory. Seated in front of them are Kate Pawnee Leggings Fools Crow (left) and Frank Fools Crow. (Courtesy of Jace DeCory.)

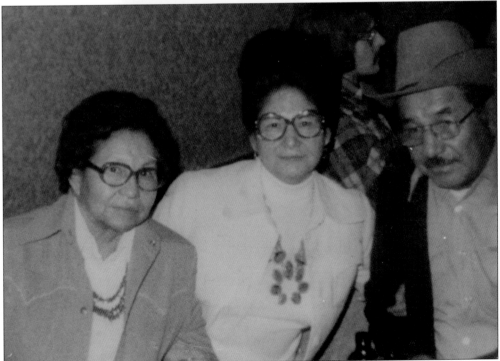

CADOTTE FAMILY. This photograph was taken in the 1970s at the University of North Dakota in Grand Forks. From left to right are Verna Cadotte, Dorothy Cadotte, Gusey Lentz, and Roger Cadotte. (Courtesy of Jace DeCory.)

DAWSON, SAM, AND JUNIOR DECORY. Sam Decory (center) poses with his sons Dawson (left) and Junior. Sam was a decorated war veteran and the husband of Jace DeCory. This photograph was taken in 1997. (Courtesy of Jace DeCory.)

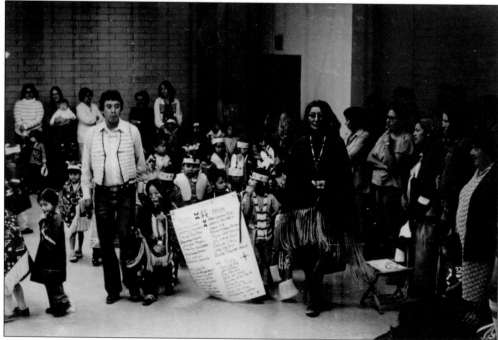

SCHOOL DANCE GROUP. This group is led by Arthur Amiotte and Mary Louise Defender Wilson. Names of the dancers are listed on the cardboard sign, as family members watch the program. Wilson is a traditional storyteller, educator, and historian. Amiotte, an Oglala Lakota, was an art instructor at Standing Rock Community College at this time. (Courtesy of Donovin Sprague.)

THERESE MARTIN. Therese Martin grew up in the Kenel, South Dakota, area and is a descendant of the leader Mad Bear. She is a cousin to Dorothy and Verna Cadotte. This photograph was taken in the 1970s at Grand Forks, North Dakota. Therese is now 98 years old. (Courtesy of Jace DeCory.)

BUFFY SAINTE-MARIE. Sainte-Marie (center) is a Canadian-American Cree singer-songwriter, composer, visual artist, educator, and social activist. She has released many music recordings. This photograph was taken in the mid-1970s in Grand Forks. Seen with her are, at left, Jessica Mason (Assiniboine Sioux, Fort Peck, Montana), and Dorothy Cadotte Cuny Lentz (Standing Rock). (Courtesy of Jace DeCory.)

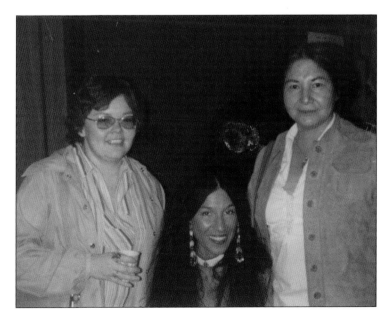

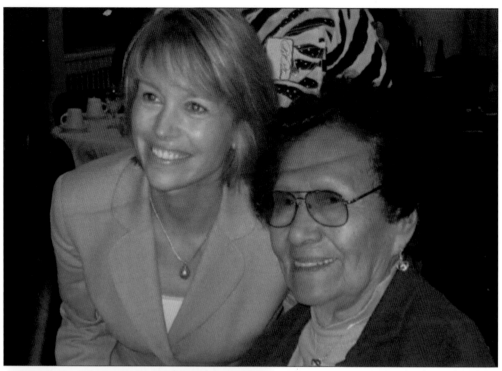

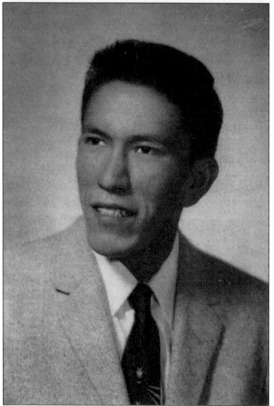

STEPHANIE HERSETH SANDLIN. Sandlin (left) represented South Dakota in the US Senate from 2004 to 2011. She poses here with Therese Martin. Later, Martin gave this photograph to her niece, Jace DeCory. At the time, Sandlin was the youngest woman serving in the House of Representatives, and the first female to represent South Dakota. Sandlin served on several committees of interest to her constituency, including the Natural Resources Committee, which made policy of concern to those at Standing Rock. (Courtesy of Jace DeCory.)

WILLIAM HELPER SR. William Helper's Indian name was Wawokiya, and he was born in 1937. His parents were Wallace and Julia Helper, and he played with the All American Indians basketball team. He married Mary Ann Helper, and their family consisted of Billie Jo, Willow Imogene, Wilma Elizabeth, William Franklin, and Michelle Rose. William passed away in 2013. (Courtesy of Jace DeCory.)

IMOGENE NOREEN TAKEN ALIVE. Born in 1931 to Wallace and Julia (Dog Eagle) Helper near Little Eagle, South Dakota, Imogene's Indian name was Wahachan Ka Waste Win. She married Peter Taken Alive. She was a homemaker, seamstress, baker, and cook, and served as a member and president of the Sitting Bull School Board of Education at Little Eagle for many years. She was an advocate of revitalizing the Lakota language in the schools and communities. They had a large *tiospaye* (extended family). Imogene passed away in 2013. (Courtesy of Jace DeCory.)

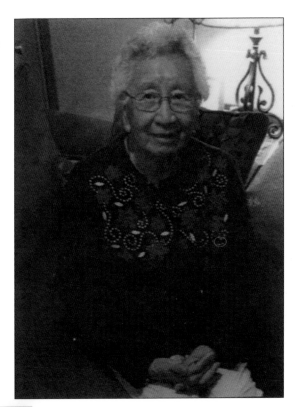

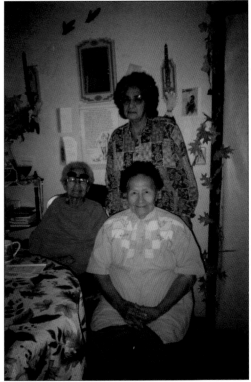

HOME OF THERESE MARTIN. Verna Cadotte (left), Arlene Jordan Hotchkiss (standing), and Therese Martin pose in 2004 in Fort Yates. Cadotte was born in 1915 and lived in Mad Bear country along the Missouri River at Standing Rock. She graduated from Flandreau High School in 1939 and worked as a registered nurse for several years with the Indian Health Service. She spent her retirement at Standing Rock visiting her cousin and best friend, Therese Martin. She lived until 2010. Hotchkiss lives in Kenel. Martin was born in 1916 and is now 91 years old. (Courtesy of Jace DeCory.)

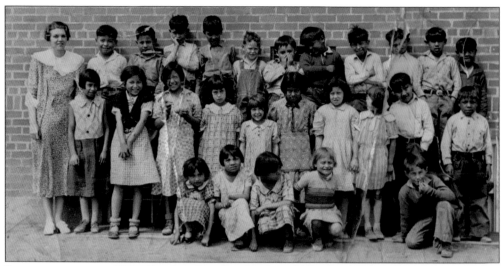

SCHOOLCHILDREN AT TWIN BUTTES. Standing Rock and Fort Berthold children pose for a class photograph in the early 1920s at Elbowoods, North Dakota, on the Fort Berthold Reservation. Among them is Zona Loans Arrow, standing in the second row second from left with hands crossed. On her left is her stepsister Lorraine Little Owl and on her right is stepsister Christine Little Owl Victoria. "Zona" Loans Arrow was born at Shields, North Dakota, to Sherman and Josephine (Iron Bull) Iron Shield in 1928. She was raised and educated at Shields, Cannonball, Standing Rock, and Twin Buttes on the Fort Berthold Reservation. She married Sampson Two Shields. After his death, she married Casper Thunder Hawk and then John Loans Arrow. She passed away in 2007. (Courtesy of Jeanette Two Shields.)

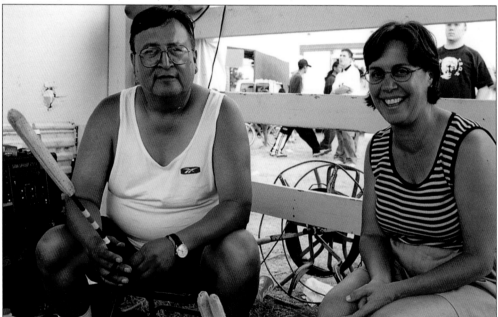

EARL BULLHEAD AND MARGARET RAMEY CLAYMORE. This photograph was taken in 1999 at the Bear Soldier Powwow in McLaughlin, South Dakota. Earl Bullhead is a teacher and recording artist. He records powwow songs and ceremonial songs. (Courtesy of Dennis J. Neumann, *United Tribes News.*)

JACE DECORY AND VERNA CADOTTE. Verna Cadotte (left) and Jace Cuney DeCory pose in 1998 in Spearfish, South Dakota. DeCory is a member of the Cheyenne River Sioux Tribe and has family ties to other Lakota Nations. She is a professor of American Indian Studies at Black Hills State University in Spearfish. (Courtesy of Jace DeCory.)

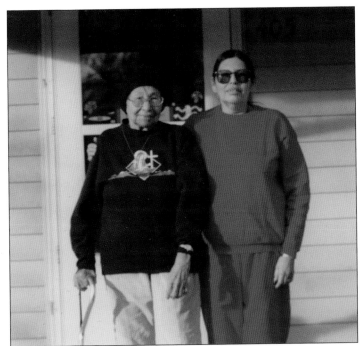

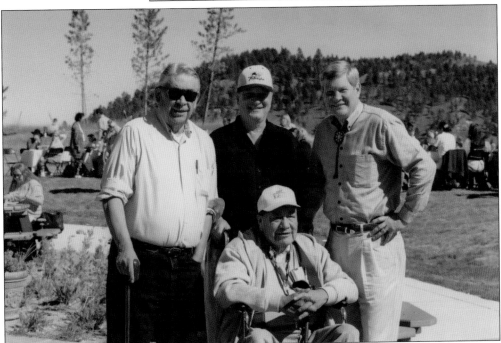

LEADERS. Shown here are, from left to right, Vine Deloria Jr., Tom Katus, Gerald One Feather (seated), and Tim Johnson. Deloria was an author and educator. Katus and Johnson served the people in South Dakota in political offices. Gerald One Feather received three honorary doctorate degrees and founded Oglala Lakota College. He also served as president of the Oglala Lakota at Pine Ridge Reservation. His parents were Elva and Joe One Feather. This photograph was taken in 2003. (Courtesy of Jace DeCory.)

DEL IRON CLOUD. Del Iron Cloud is Hunkpapa Lakota and lives in Rapid City, South Dakota. He has completed wall murals for Grand River Casino in Mobridge; Prairie Knights Casino in Fort Yates; Denver International Airport; Royal River Casino in Flandreau, South Dakota; Lode Star Casino in Fort Thompson, South Dakota; Golden Buffalo Casino in Lower Brule, South Dakota; Rosebud Casino near Valentine, Nebraska; and Prairie Winds Casino at Pine Ridge Reservation. (Courtesy of Donovin Sprague.)

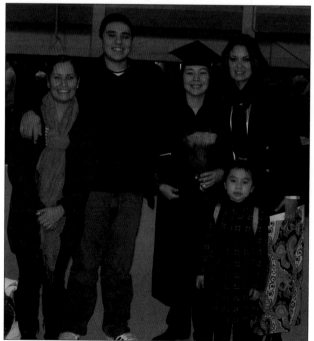

GRADUATION DAY. Pictured here are, from left to right, Billi Jo Beheler, Spencer Fox, Rosie Sprague (Two Shields), Kerry Libby, and Ella Sprague (in front). They are gathered at the graduation of Rosie Sprague from Black Hills State University in Spearfish, South Dakota. She is assistant director of the Center of Indian Studies at the university. Beheler is from Kenel, Fox is from Bismarck, and Libby lives in McLaughlin. All are enrolled members of Standing Rock. (Courtesy of Donovin Sprague.)

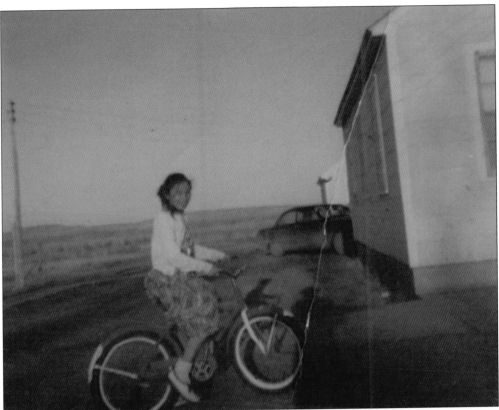

JAN TWO SHIELDS. Jan Two Shields rides her bicycle as a young girl. She lives in Cannonball, North Dakota, and her parents were Samson Two Shields and Victoria "Zona" Loans Arrow. (Courtesy of Jeanette Two Shields.)

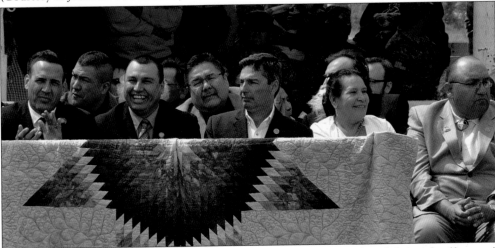

TRIBAL CHAIRMEN AND COUNCIL REPRESENTATIVES. Shown here are, from left to right, (first row) Jesse McLaughlin, Richard McCloud, and Cody Two Bears; (second row) Russell McDonald, Joe Dunn, Avis Little Eagle, and Randy White. Avis Little Eagle is a Standing Rock councilwoman. This photograph was taken when President Obama visited Cannonball in the summer of 2014. (Courtesy of Dennis J. Neumann, *United Tribes News*.)

SPRAGUE FAMILY. Shown here are, from left to right, Rhiana Pudwill, Dylan Pudwill (holding baby Nels Sprague), Ava Sprague, and Ella Sprague. Rhiana is holding the dog Missy, and Ava and Ella are holding Jacob. (Courtesy of Donovin Sprague.)

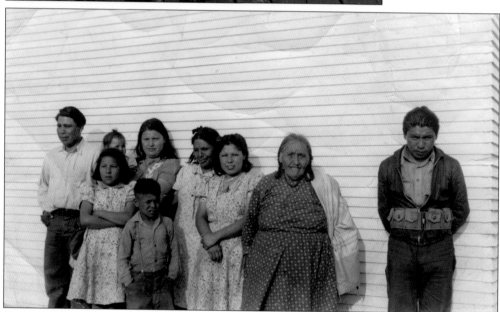

FLYING BY/BYE AND GRINDSTONE FAMILIES. These families lived at Little Eagle, South Dakota. Joe Flying Bye (Kangi Hotanka) was a respected medicine man, born in 1919 to Nathan and Eloise (Grindstone) Flying By/Bye. While serving in the Army, he was wounded in the right leg. His brother Moses was born in 1914. These families are related; the baby Cordelia is the author's aunt. Posing here around 1938 are, from left to right, (first row) Romona Grindstone and Reynolds Bearshield; (second row) Rev. Moses Flying Bye, Cordelia Flying Bye Benoist (baby), Leona Flying Bye, Ella Grindstone (Shoots Walking), Amy Grindstone, Unci Stella Grindstone, and Joe Flying Bye. (Courtesy of Donovin Sprague.)

KERRY LIBBY. Pictured here in her regalia when she was selected Miss Standing Rock 1988 at the Fort Yates annual powwow, Kerry Libby attended Standing Rock High School in Fort Yates. Today, she is the director of Standing Rock Institute of Natural History at Fort Yates, North Dakota. Her mother is Jan Two Shields. (Courtesy of Jeanette Two Shields.)

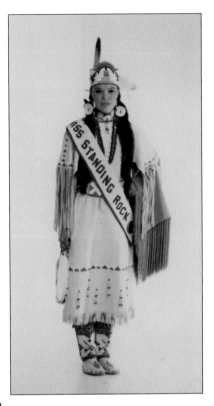

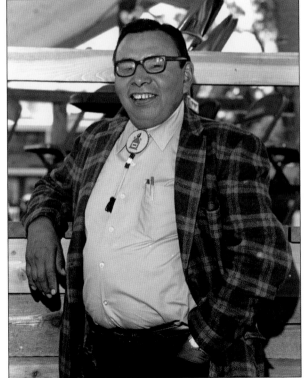

MELVIN WHITE EAGLE. Born at Cannonball, North Dakota, in 1926, White Eagle served as chairman of Standing Rock in 1970–1971 and 1973–1975. He was also chairman of the board of directors of United Tribes Educational Training Center. He retired from United Tribes in 1995 and passed away in 1999. (Courtesy of Dennis J. Neumann, *United Tribes News*.)

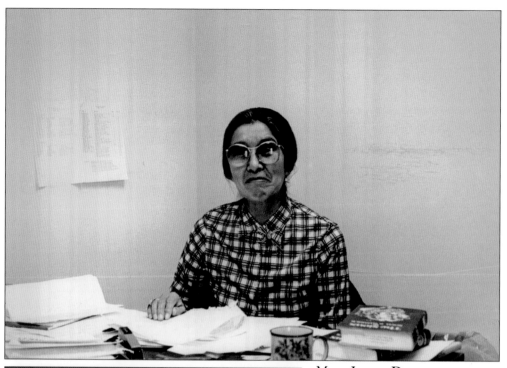

MARY LOUISE DEFENDER WILSON. Wilson, whose Lakota name is Gourd Woman, is a storytelling recording artist who has received numerous awards. She learned Dakota stories from her mother, Helen Margaret See the Bear, and from her grandmother. In 1954, she was the first Miss Indian America. (Courtesy of Donovin Sprague.)

CAROLE KLOSS. Carole LaMonte Kloss was born in Fort Yates and now lives in California. Her parents were Collins LaMonte, who was born in Wakpala in 1916, and Bertha Huber. Anna (Anne) LaMonte Buckner, Carole's grandmother, was a cook at the Martin Kenel School at Standing Rock. (Courtesy of Carole Kloss.)

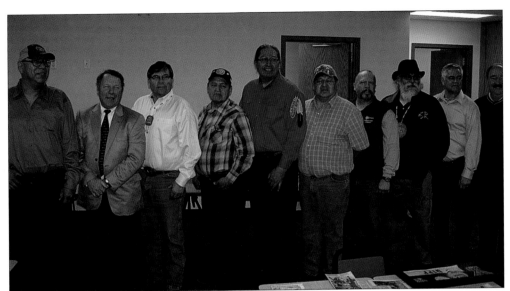

OLD WARRIORS. On March 16, 2013, members of the famed 1973 Fort Yates Warriors basketball team gathered at United Tribes Technical College in Bismarck for the 40th anniversary of their thrilling Class A state high school basketball championship. From left to right are Ken Walks, Coach Clark Swisher, Albert Gipp, Verle Red Tomahawk, Darrell Eaglestaff, Tony Bobtail Bear Sr., Kevyn Heck, Wyman Archambault, Gus Claymore, and Assistant Coach Sherman Laubach. Not pictured is Jesse "Jay" Taken Alive. (Courtesy of Dennis J. Neumann, *United Tribes News*.)

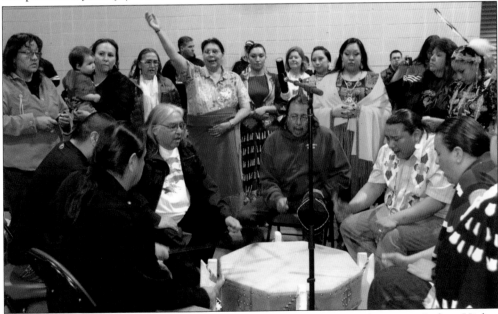

GOODHOUSE FAMILY. The Goodhouse family performs at the 2011 American Indian Higher Educational Consortium in Bismarck. The consortium comprises all the American Indian colleges in the United States. Dakota Goodhouse and Sissy Buckley Goodhouse are instructors at United Tribes Technical College. Dakota's parents are from Wakpala, South Dakota, and Sissy is originally from Cannonball. Sissy is at center with her arm raised, and Cedric Goodhouse is at her right. (Courtesy of Dennis J. Neumann, *United Tribes News*.)

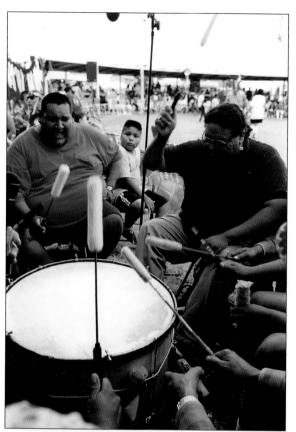

LAKESIDE DRUM GROUP. The Lakeside drum group of Wakpala performs in 1999. Vaughan Three Legs holds the raised drum stick. He was known as M.C. Stoney at KLND-FM radio. (Courtesy of Dennis J. Neumann, *United Tribes News*.)

POWWOW DRUM GROUP. Singer Earl Bullhead is at center, facing the camera. At left with glasses is Terry Yellow Fat. Archie Fool Bear is standing at center, in the blue shirt. He is recording the drum group. (Courtesy of Dennis J. Neumann, *United Tribes News*.)

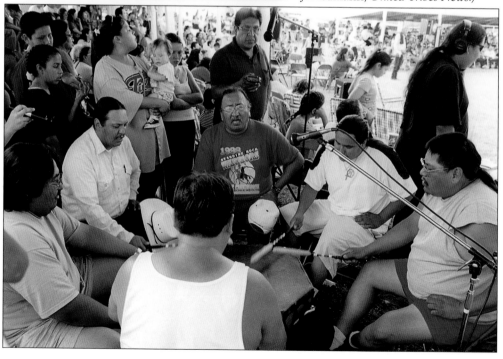

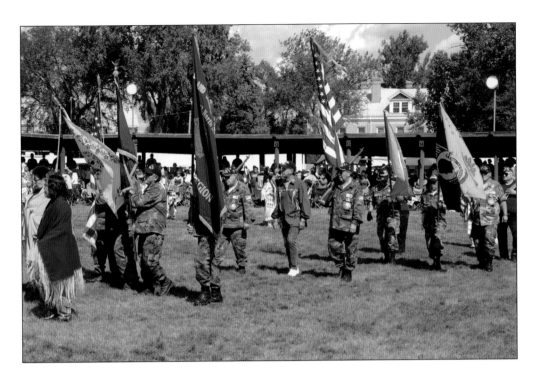

POWWOW GRAND ENTRY. These photographs were taken at the United Tribes International Powwow in Bismarck, North Dakota. The veterans are leading the group in the grand entry to the event. (Both, courtesy of Dennis J. Neumann, *United Tribes News*.)

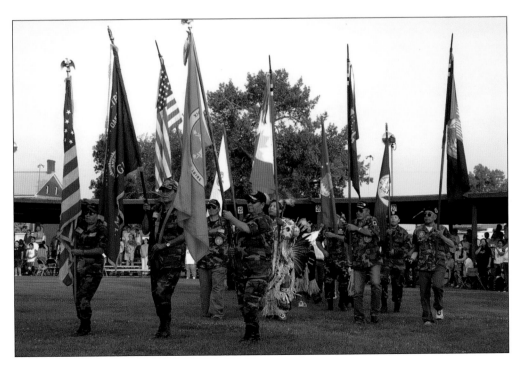

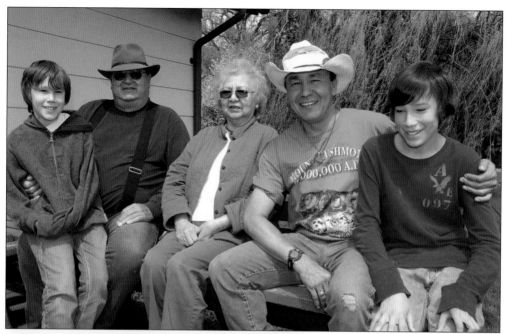

KEEPS EAGLE FAMILY. George and Marilyn Keeps Eagle pose with their family. They are from Long Soldier District and are lifelong residents of the area. George is a rancher, and Marilyn retired from the Bureau of Indian Affairs, where she worked with a social service agency. They are pictured here with their grandsons Mitchell (far left) and Kyle (far right) and their son Wade Keeps Eagle (second from right). (Courtesy of Dennis J. Neumann, *United Tribes News*.)

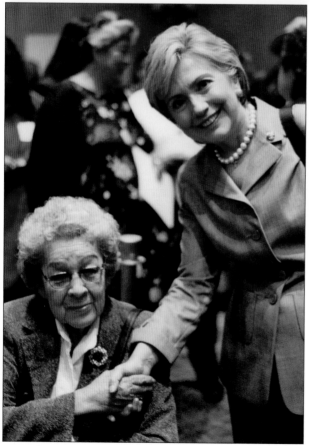

MARGARET HALSEY TEACHOUT AND HILLARY CLINTON. Margaret Teachout was from the Long Soldier District. This photograph was taken in 2004. (Courtesy of Dennis J. Neumann, *United Tribes News*.)

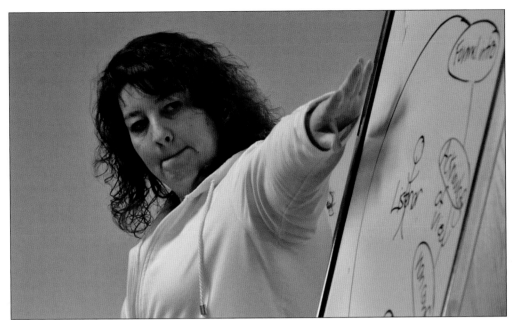

Dr. Cheryl Kary. An adjunct professor at United Tribes Technical College, Dr. Kary is pictured here in a 2015 presentation at UTTC. She is from Standing Rock. (Courtesy of Dennis J. Neumann, *United Tribes News*.)

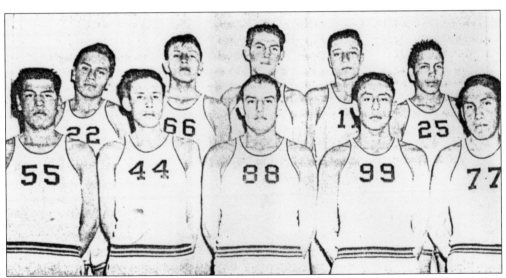

1956 Fort Yates Warriors. This team was the North Dakota Class B champions. From left to right are (first row) Ronald Archambault, Walter Yellow Hammer, Russell Lawrence, Sylvester Vermillion, and Leonard Village Center; (second row) Wilbur Pleets, Arnold Kills Crow, Larry Hayes, Robert Gipp, and Joe Yellow Hammer. Other team members and leaders were Leslie Bobtail Bear, Wallace Gulluzi (coach), assisted by Miles Bollinger and student manager Raymond Dunn. Cheerleaders were Rose Mary Voight, Marilyn Thompson, Ardis McLaughlin, and Theresa See Walker. (Courtesy of Dennis J. Neumann, *United Tribes News*.)

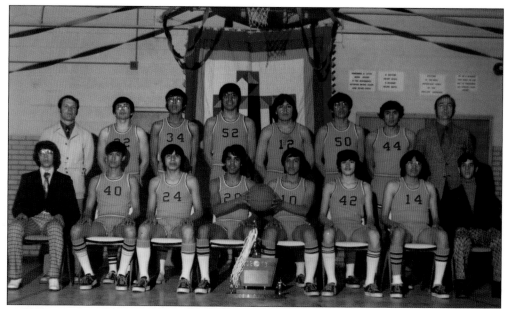

1973 BASKETBALL CHAMPIONS. The 1973 Fort Yates basketball team won the North Dakota Class A championship. From left to right are (first row) Sheldon Spiegelman, two unidentified, Oliver Eagleman (No. 20), Verle Red Tomahawk (No. 10), unidentified, Jay Taken Alive (No. 14), and unidentified; (second row) Sherman Laubach, Albert Gipp Jr. (No. 22), Ken Walks (No. 34), Darrell Eaglestaff (No. 52), Roger Goudreaux (No. 12), Bill Eaglestaff (No. 50), Wyman Archambault (No. 44), and Clark Swisher Jr. One of the players in the first row is Jerry Grey Bear. (Courtesy of Dennis J. Neumann, *United Tribes News.*)

JAN TWO SHIELDS AND AARON LIBBY. Jan and her son Aaron are pictured in 1970 in Seattle. They were viewing the Seafair hydroplane races, a summer festival celebration. Aaron Libby was an officer with the Seattle Police Department from 1993 to 2003. He now serves as a dispatcher for the department. (Courtesy of Jeanette Two Shields.)

1971 FORT YATES BASKETBALL.
The 1971 varsity team consisted
of Ken Bahm, Darrel Eaglestaff,
Bob Eaglestaff, Fred Luckens,
Richard Hach, Bill Luckens,
John Barker, Ron Gross, Roger
Goudreaux, Virgil Taken Alive,
Frank One Feather, and Jim
Disrud. They were contenders
for the North Dakota state
basketball championship.
(Courtesy of Dennis J. Neumann,
United Tribes News.)

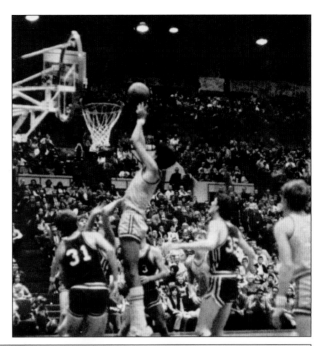

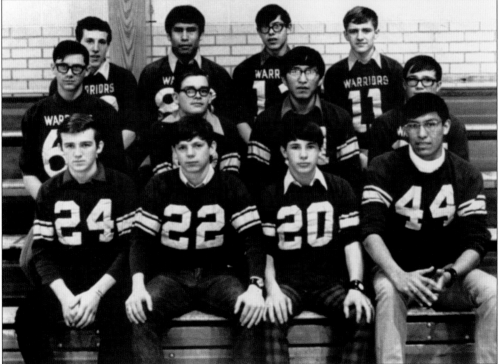

1971 FORT YATES FOOTBALL PLAYERS. The Fort Yates seniors on the football team have gathered
for a photograph. From left to right are (first row) Glen Weigel, Jim Disrud, Mark Thomas, and
Bob Eaglestaff; (second row) Ernest Jochium, D. Schaf, Virgil Taken Alive, and Pat Becker; (third
row) W. Schaf, Frank One Feather, Claude Netterville, and John Barker. (Courtesy of Dennis J.
Neumann, *United Tribes News.*)

UNITED TRIBES BASKETBALL. This 1983 basketball activity is taking place in the old gymnasium at United Tribes Educational Technical Training Center in Bismarck. (Courtesy of Dennis J. Neumann, *United Tribes News.*)

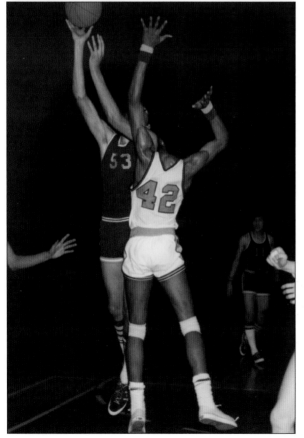

FORT YATES WARRIORS BASKETBALL. Bill Eaglestaff is shooting over ? Trader during a contest between Fort Yates and Minot, North Dakota, in 1973. (Courtesy of Dennis J. Neumann, *United Tribes News.*)

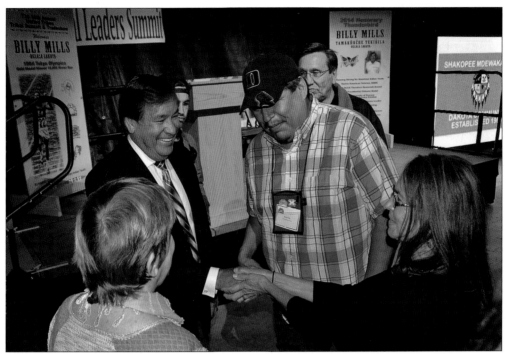

BILLY MILLS AT TRIBAL LEADER'S SUMMIT. Shown here at the 18th annual United Tribes Tribal Summit and Trade Show is Billy Mills (left). An Oglala Lakota, he won the gold medal at the 1964 Tokyo Olympics in the 10,000-meter run. Kevin Finley, former UTTC employee, is at right. Joanie M. Ramey-Neumann of Bismarck is shaking hands with Mills. She is a graduate of the UTTC practical nursing program. (Courtesy of Dennis J. Neumann, *United Tribes News*.)

RODEO ACTION AT FORT YATES. Phil Baird is at the 1977 Fort Yates rodeo, riding the horse Boots in the saddle bronc competition. Baird is the former UTTC interim president (2014) and former UTTC vice president of academic, career, and technical education. He now works with the North Dakota Cowboy Hall of Fame. Rodeo competition is very popular, and many are held throughout the summer. (Courtesy of Dennis J. Neumann, *United Tribes News*.)

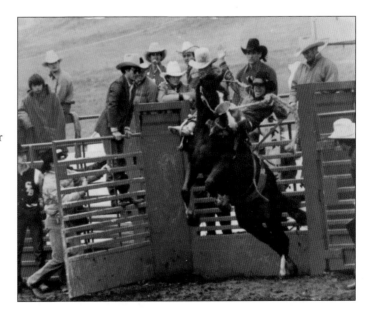

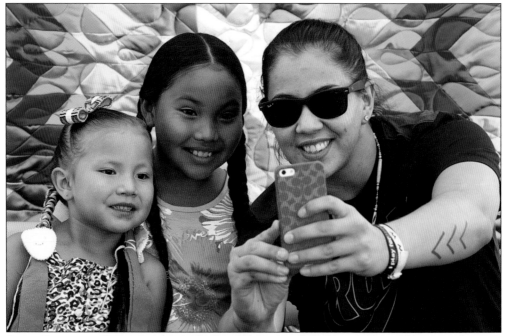

SHONI SCHIMMEL. Shown here are Mikaylee Old Coyote (left), Heaven Rose Old Coyote (center), and WNBA star Shoni Schimmel. Sisters Mikaylee, four, and Heaven Rose, ten, are from Ethete, Wyoming. They competed in the Junior Girl's dance categories at the 2014 United Tribes International Powwow. They took this selfie with guest celebrity athlete Schimmel, who was an All-American college basketball player at the University of Louisville and a first-round draft pick of the WNBA's Atlanta Dream. Shoni was raised on the Confederated Tribes of the Umatilla Indian Reservation in Oregon. (Courtesy of Dennis J. Neumann, *United Tribes News*.)

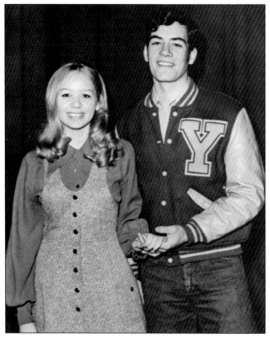

FORT YATES HIGH SCHOOL KING AND QUEEN. Posing here are the 1971 high school queen and king, Debbie Barth and Joe Luger. (Courtesy of Dennis J. Neumann, *United Tribes News*.)

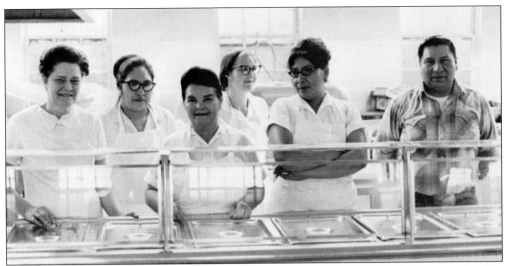

COOKS AT FORT YATES HIGH SCHOOL. Posing here are the cooks for Fort Yates High School in 1971. From left to right are Mrs. Birdsall, Mrs. Bullhead, Mrs. Cadotte, Mrs. Bookless, and Mrs. Kidder. The cafeteria janitor at right is Felix Kidder. (Courtesy of Dennis J. Neumann, *United Tribes News.*)

AMERICAN HORSE FAMILY. The American Horse family performed a gospel music program at the Veterans Memorial Building in Cannonball. Pictured here are Antoine American Horse Jr. and his wife, Verdelia White Buffalo American Horse, with their children Rose (far left) and Yamni. (Courtesy of Dennis J. Neumann, *United Tribes News.*)

AMERICAN HORSE FAMILY AT CANNONBALL. The American Horse family performs gospel music at Cannonball, North Dakota. (Courtesy of Dennis J. Neumann, *United Tribes News*.)

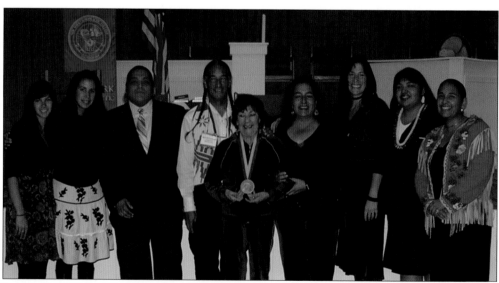

LOCKE FAMILY. Pictured here from left to right are Nia McKnight, Kiana Sabla, Duta Flying Earth, Kevin Locke, Frances Milligan, Winona Flying Earth, Sheridan McKnight, May Flying Earth, and Kimimila Locke. This photograph was taken when Patricia Locke was posthumously inducted into the National Women's Hall of Fame. (Courtesy of Dennis J. Neumann, *United Tribes News*.)

DAVID M. GIPP AND JODI ARCHAMBAULT GILLETTE. David Gipp is the former president of United Tribes Technical Center. He is now president emeritus of the college and is a consultant for UTTC. He and Gillette are from the Long Soldier District. She was a senior policy advisor for Native American Affairs to President Obama and now works with a legal office in Washington, DC. (Courtesy of Dennis J. Neumann, *United Tribes News.*)

GIPP FAMILY. This is the Gipp family from Standing Rock. Their mother, Margaret Teachout, is at center. Also pictured are, from left to right, brothers Gerald, Robert, and David. (Courtesy of Dennis J. Neumann, *United Tribes News.*)

ROSIE TWO SHIELDS AND NICK ROMERO. These children are pictured at the Fort Yates Powwow and Fair in 1985–1986. Rosie Sprague (Two Shields) is currently the assistant director of the Center for American Indian Studies at Black Hills State University in Spearfish, South Dakota. She graduated with a master's degree from the University of South Dakota. Nick Romero is the son of Leslie White Temple-Gipp and grandson of the late Albert and Eunice Gipp. (Courtesy of Jeanette Two Shields.)

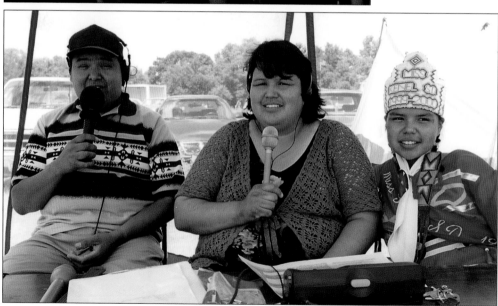

KLND-FM RADIO AT THE LITTLE EAGLE POWWOW, 1999. Brittany Bear Catches (far right) was crowned Miss Kenel, South Dakota, for 1999–2000, during this broadcast with Charles Shoots the Enemy and Deanne Bear Catches. (Courtesy of Dennis J. Neumann, *United Tribes News*.)

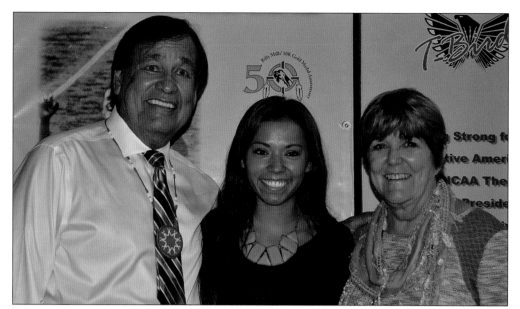

UNITED TRIBES TRIBAL SUMMIT AND TRADE SHOW. Guests of this event included 1964 Olympic champion Billy Mills (left) and his wife Pat Mills (right), as well as Brittany Brown Otter (center). Brittany won three individual North Dakota state track titles and led the Bismarck Demons to the Class A championship. As a senior, she was named the Gatorade North Dakota Girls Track and Field Athlete of the Year. (Courtesy of Dennis J. Neumann, *United Tribes News*.)

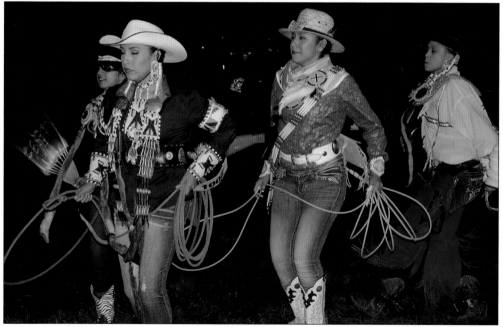

HAT AND BOOT COMPETITION. At left, in front, Shaydee Pretends Eagle of Spirit Lake competes in the Hat and Boot Competition during the 45th annual United Tribes International Powwow. This popular new category was added to emphasize the important connection that Native people have with the horse culture. Pretends Eagle also won first place in the Women's Jingle Dress competition. (Courtesy of Dennis J. Neumann, *United Tribes News*.)

SUSAN POWER. The author of several publications, Power was born in Chicago and is an enrolled member of Standing Rock. She earned a law degree from Harvard University. Her mother, Susan Kelly Power, moved to Chicago and is a descendant of Two Bear of the Yanktonai. (Courtesy of Dennis J. Neumann, *United Tribes News*.)

PHYLLIS YOUNG. Hailing from Long Soldier District, Young has been an advocate for American Indian affairs throughout the country. (Courtesy of Dennis J. Neumann, *United Tribes News*.)

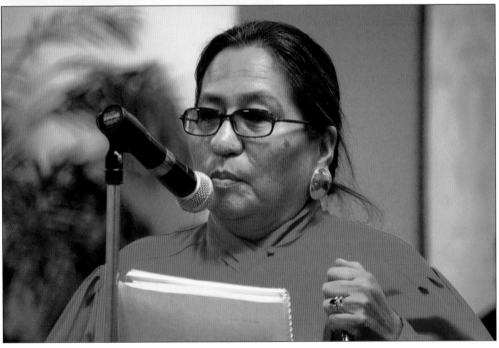

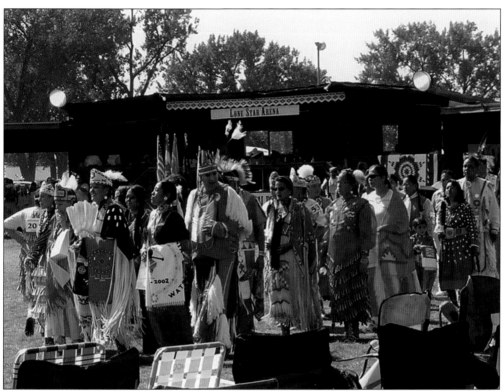

POWWOW AT UTTC. The United Tribes Training Center Powow was founded in 1969. The brick buildings on the campus grounds were built between 1900 and 1910 as a military base. This was the second Fort Abraham Lincoln. United Tribes of North Dakota Development Corporation acquired ownership in 1974. In 1982, it became a postsecondary vocational school. The current president is Dr. Leander "Russ" McDonald. (Courtesy of UTTC.)

CHARLES MURPHY. A longtime leader at Standing Rock, Murphy served as tribal chairman in 1983–1993, 1997–2005, and 2009–2013. He is from Porcupine, North Dakota. (Courtesy of Dennis J. Neumann, *United Tribes News*.)

SHARON TWO BEARS. Sharon McLaughlin Two Bears is a Standing Rock councilwoman from the Porcupine District. Her husband is Albert Two Bears, and they live in Cannonball. (Courtesy of Dennis J. Neumann, *United Tribes News*.)

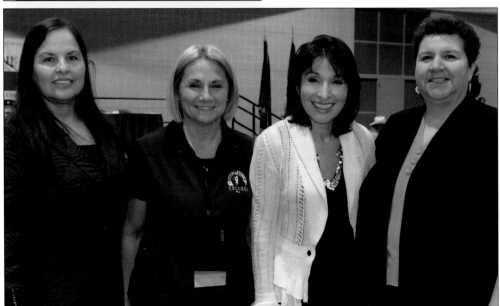

SUCCESSFUL WOMEN. Shown here are, from left to right, Dr. Cynthia Linquist, Dr. Koreen Ressler, Hattie Kaufman, and Dr. Laurel Vermillion. Dr. Linquist is president of Cankdeska Cikana Community College at Fort Totten, North Dakota. Dr. Ressler is vice president of academics at Sitting Bull College. Kaufman, an author and a correspondent for CBS News and ABC News, was the first Native American to file a report on a network news broadcast. Dr. Vermillion is president of Sitting Bull College at Fort Yates. (Courtesy of Dennis J. Neumann, *United Tribes News*.)

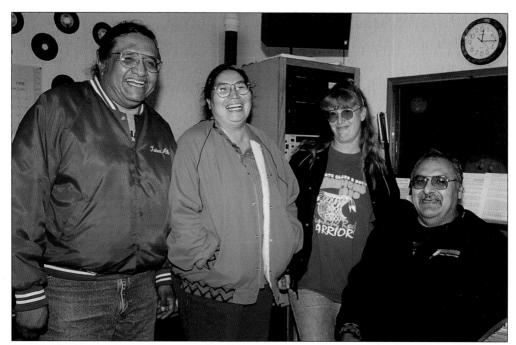

KLND-FM Radio Hosts. The Saturday afternoon variety show hosts at KLND-FM radio pose in 1998. They are, from left to right, Jay Taken Alive, Cheryl Taken Alive, Charlotte Archambault, and Wyman Archambault. (Courtesy of Dennis J. Neumann, *United Tribes News*.)

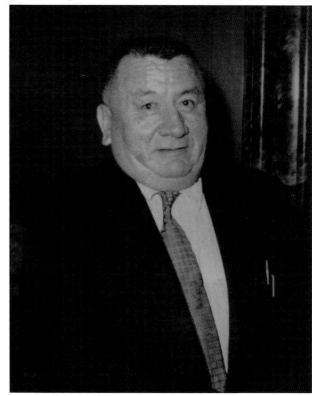

Theodore "Tiny Bud" Jamerson. A former Standing Rock tribal chairman from the Running Antelope District, Jamerson was instrumental in bringing the tribes of North Dakota and South Dakota together and acquiring the former Fort Lincoln land base as a training facility for tribal people. (Courtesy of Dennis J. Neumann, *United Tribes News*.)

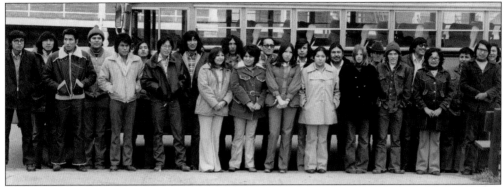

UNITED TRIBES TECHNICAL COLLEGE STUDENTS. UTTC students and staff pose in the 1970s. The school was founded in 1969 by an intertribal organization. The mission of the institution continues to be to provide "not only occupational education and training but also individual and social skills in a culturally relevant setting, with an emphasis on children and families." (Courtesy of Dennis J. Neumann, *United Tribes News*.)

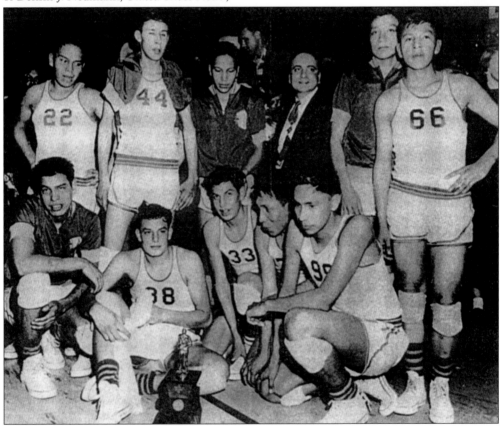

1956 STATE CHAMPIONS. The 1956 Fort Yates Warriors won the North Dakota Class B basketball championship. Posing here are, from left to right, (first row) Ronald Archambault, Russell Lawrence, Larry Hayes, Leonard Village Center, and Sylvester Vermillion; (second row) Wilbur Pleets, Walter Yellow Hammer, Joe Yellow Hammer, head coach Wallace Galluzzi, Robert Gipp, and Arnold Kills Crow. Not pictured are Leslie Bobtail Bear, student manager Raymond Dunn, and assistant coach Miles Bolinger. (Courtesy of UTTC.)

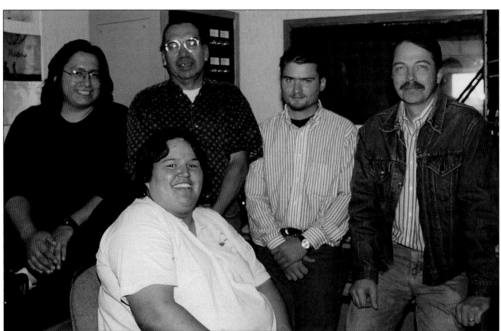

KLND Radio Family. KLND-FM radio employees pose in 1998. Seated in the front is Deanne "Sugar Bear" Bear Catches, a volunteer coordinator and disc jockey. Shown in back are, from left to right, Mike Kills Pretty Enemy Jr. (production manager), Harold Iron Shield (news director), Aaron Lafferty (development director), and Dennis Neumann (station manager). (Courtesy of UTTC.)

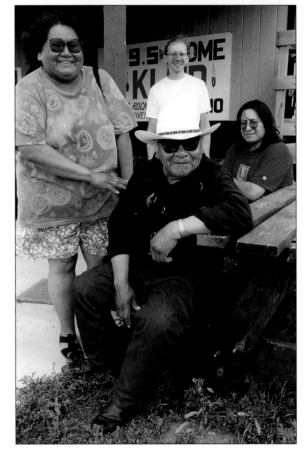

KLND Anniversary. These KLND radio associates take time out in 1999 to be photographed at the second anniversary of the founding of the radio station. Seated are Joe Flying Bye (left) and Mike Kills Pretty Enemy. Standing are Marge Edwards (left) and an unidentified recording engineer from Wisconsin. Joe Flying Bye practiced traditional Lakota ways. His birth date was listed incorrectly so that he could join the military as a young man. (Courtesy of UTTC.)

TED AND JENNY GAYTON EAGLE.
The Eagle family had a gospel
program on KLND radio. Ted also
collected cars. (Courtesy of Dennis
J. Neumann, *United Tribes News*.)

SAMSON TWO SHIELDS. Samson
Two Shields married Victoria
Zona Iron Shield in 1946 at
Standing Rock. He was the father
of Jan Two Shields of Cannonball,
North Dakota, who provided the
photograph. On this day, Samson
was traveling on horseback.
(Courtesy of Jeanette Two Shields.)

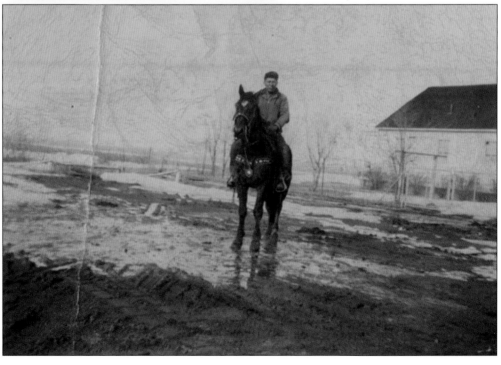

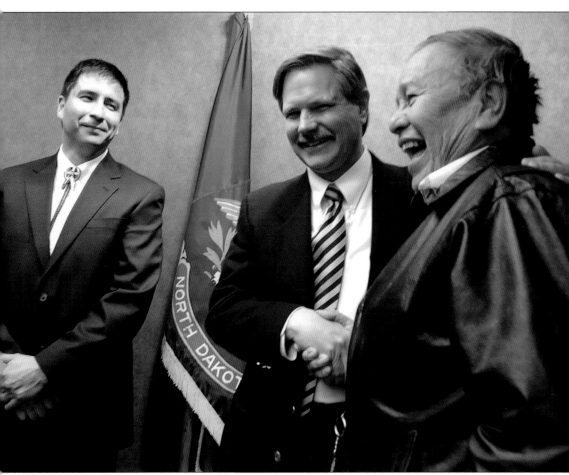

HONORING ATHLETIC ACHIEVEMENTS. Scott Davis (left) acts as the executive director of the North Dakota State Indian Affairs Commission out of Bismarck. Sen. Ed Schaeffer (center) is shaking hands with Wilbur "Banny" Pleets, a member of the 1956 Fort Yates Warriors, who was being honored at a powwow in 2014. (Courtesy of UTTC.)

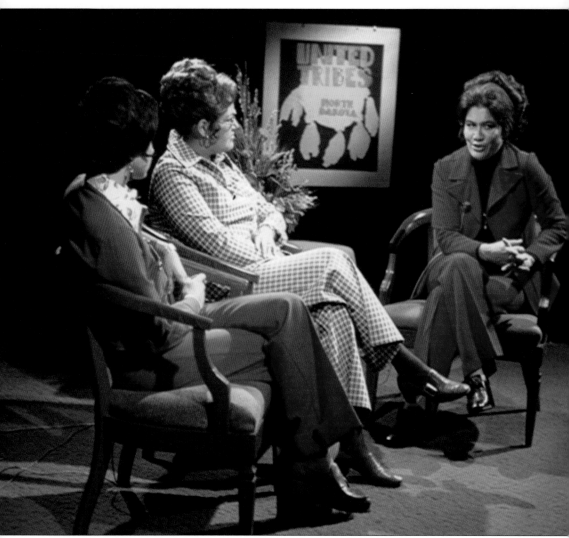

Dr. Harriet Skye. Dr. Skye is pictured here on her program *Indian Country Today*, which aired biweekly on KFYR-TV from 1972 to 1984. Skye's journalistic pursuits ultimately led to her participation in civil rights hearings. After an employment setback in her fifties, she went back to school, attending Northern Virginia Community College, and later New York University and the University of California–Berkeley. These scholastic endeavors ultimately led her to direct an autobiographical film, *The Right to Be*, which was screened at the Sundance Film Festival in 1994. (Courtesy of Dennis J. Neumann, *United Tribes News*.)

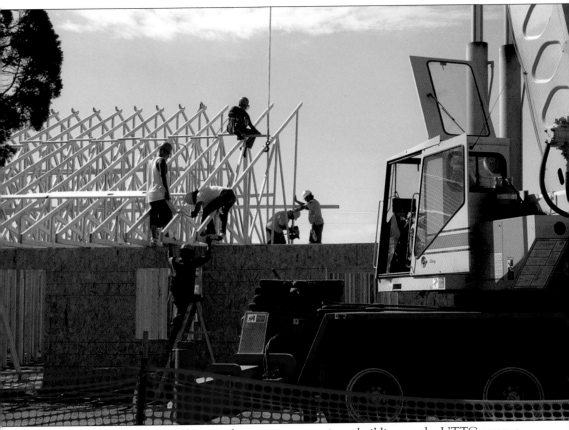

UTTC Students at Work. These students are constructing a building on the UTTC campus for educational purposes with the help of a crane. Education geared toward employment is a key component of the UTTC mission. (Courtesy of Dennis J. Neumann, *United Tribes News*.)

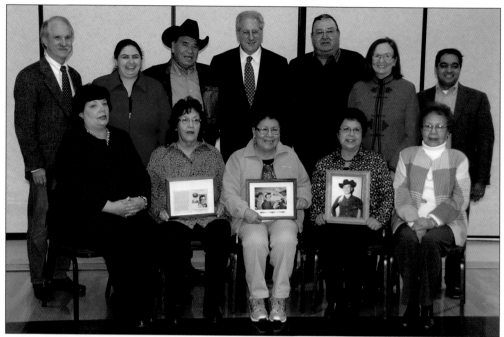

KEEPS EAGLE. George Keeps Eagle (second row, third from right) and Marilyn Keeps Eagle (first row, far right) were involved in a landmark class-action lawsuit against the US Department of Agriculture regarding the allocation of excess settlement funds. The Keeps Eagle family believes settlement funds were unjustly and discriminatorily withheld from Native American farmers and ranchers by the USDA. Helen Alkire (first row, center) is from Long Soldier District. (Courtesy of Dennis J. Neumann, *United Tribes News*.)

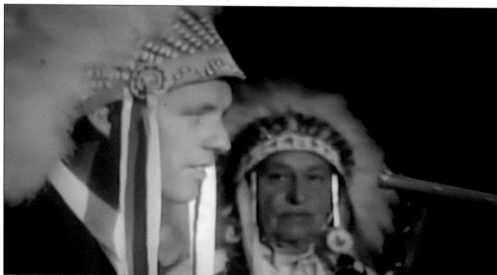

ROBERT F. KENNEDY. US attorney general Robert Kennedy attended the 20th annual conference of the National Congress of American Indians on September 13, 1963, in Bismarck. He was the keynote speaker for the conference. The image comes from video in the North Dakota News Films Archive of the State Historical Society in Bismarck. (Courtesy of Dennis J. Neumann, *United Tribes News*.)

Three

ATEYAPI OMNICIYE

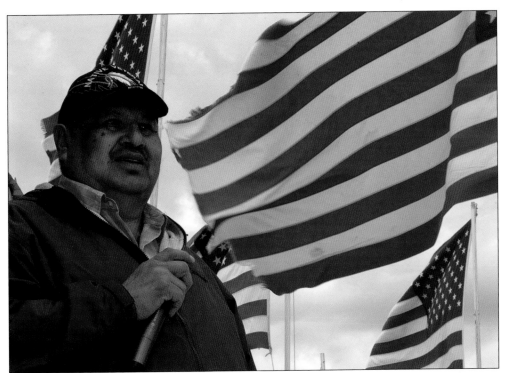

ANTHONY BOBTAIL BEAR. An *eyapaha* (announcer) at powwow events, Anthony Bobtail Bear is from the Running Antelope (Little Eagle) District. On this day, he was master of ceremonies for the 2014 Flag Day Celebration and Powwow in Cannonball, attended by Pres. Barack Obama and First Lady Michelle Obama. His one-hour monologue prior to the honored guests' arrival was filled with Indian humor and amusement for the large number of tribal members and visitors who attended. He is also a veteran. (Courtesy of Dennis J. Neumann, *United Tribes News*.)

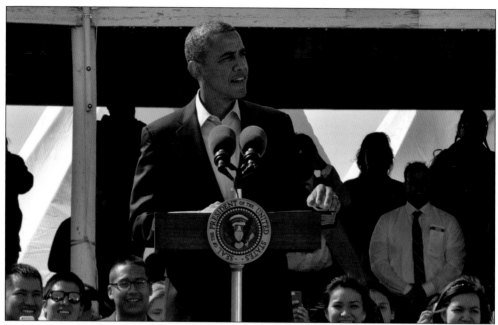

Pres. Barack Obama. US president Barack Obama addresses the people at Standing Rock from the podium platform bearing the seal of the president of the United States on June 16, 2014. (Courtesy of Dennis J. Neumann, *United Tribes News.*)

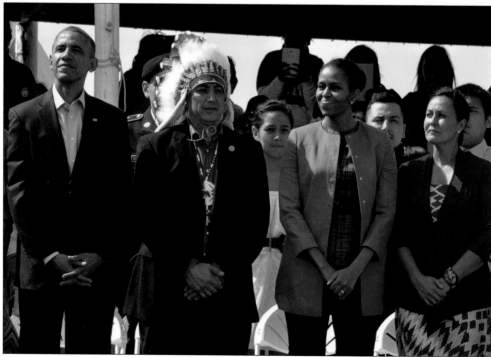

Presidential Visit to Standing Rock. Seen here during the celebration are, from left to right, Pres. Barack Obama, chairman Dave Archambault II, Michelle Obama, and Nicole Thunder Hawk Achambault. (Courtesy of Dennis J. Neumann, *United Tribes News.*)

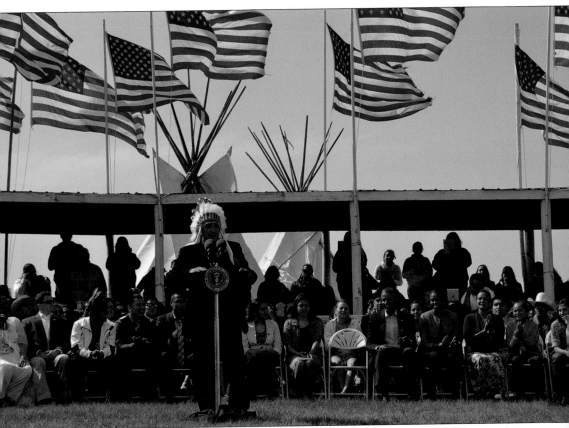

DAVE ARCHAMBAULT II. Standing Rock Sioux tribal chairman Archambault addresses the crowd while the First Lady and the president listen. Chairman Archambault noted, "If Sitting Bull were sitting here today, he'd be honored." Archambault went on to praise President Obama's efforts pertaining to Indian country, saying, "I hope this sets a precedent." (Courtesy of Dennis J. Neumann, *United Tribes News*.)

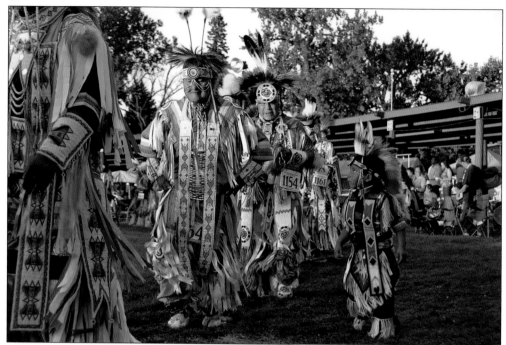

A Dance to Commemorate the Visit. These photographs portray the intricate nature of the ceremony as well as the culture committed to its heritage. In the bottom photograph, Ronnie Eagle Chasing Minnicoujou is at left. Next to him is Benny Halfe, wearing his wahpehsha regalia. (Both, courtesy of Dennis J. Neumann, *United Tribes News*.)

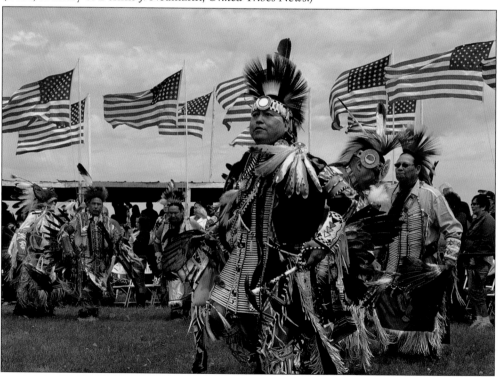

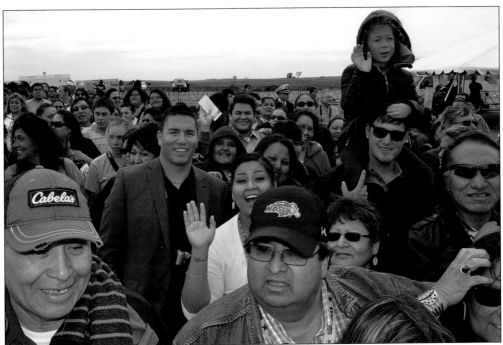

AN EXCITED CROWD. The group shown above is waiting anxiously for the arrival of President Obama at Cannonball, North Dakota. At front is Duane Silk (left) and Lelewis Gipp. The tall man left of center is Brad Hawk from the North Dakota Indian Affairs Commission. He is from Crow Creek. Randy Bear Ribs is at far right with sunglasses. The below photograph shows a group of volunteers waiting with anticipation. (Both, courtesy of Dennis J. Neumann, *United Tribes News*.)

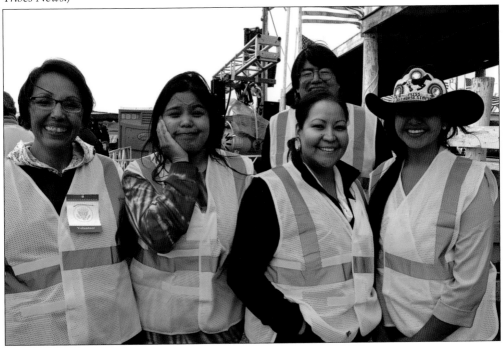

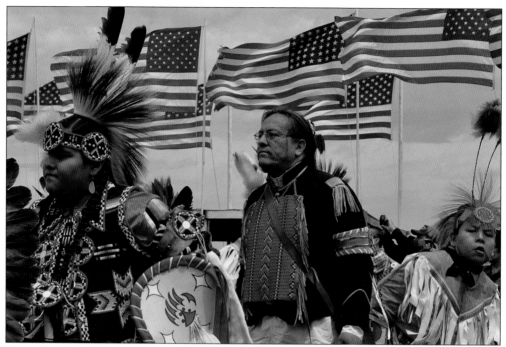

MORE POWWOW DANCERS. Mr. Goodhouse is pictured at center. At right is Cameron Ireland from Cannonball. This vibrant celebration was notable, as President Obama became the third sitting president to visit an Indian reservation. (Courtesy of Dennis J. Neumann, *United Tribes News*.)

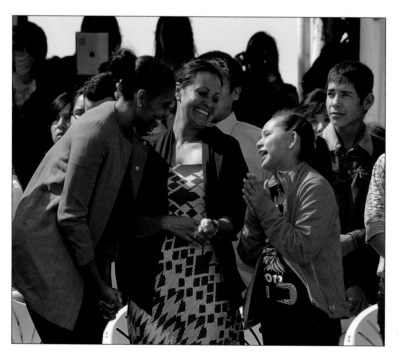

FIRST LADY MICHELLE OBAMA. Michelle Obama (left) and Nicole Archambault (center), the first lady of the Standing Rock Tribe, speak with Faith Hall, 10. Many students from the Three Affiliated Tribes in North Dakota attended this event as a part of school. (Courtesy of Dennis J. Neumann, *United Tribes News*.)

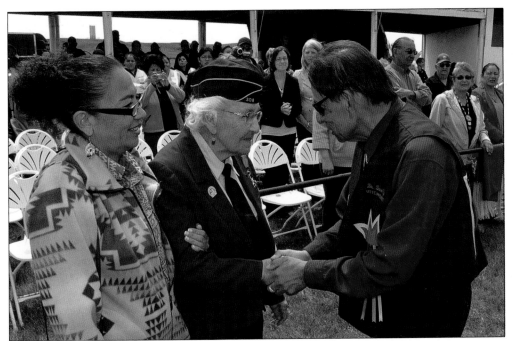

BILLI HORNBECK, MARCELLA LEBEAU, AND DAVID GIPP. Seen here shaking hands with David Gipp, LeBeau (center) is a World War II veteran who served as a nurse on the front lines. A member of the Cheyenne River Sioux Tribe, she is from the Oohenumpa Lakota band. The woman at left is Billi Hornbeck. (Courtesy of Dennis J. Neumann, *United Tribes News*.)

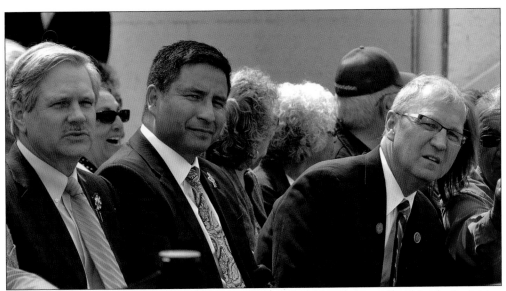

INDIAN AND STATE OFFICIALS. Notable local and state officials were also on hand for the festivities. Pictured here are, from left to right, North Dakota US senator John Hoeven, North Dakota Indian Affairs director Scott Davis, North Dakota congressman Kevin Cramer, and Dave Archambault Sr., the educator and father of the tribe's chairman. (Courtesy of Dennis J. Neumann, *United Tribes News*.)

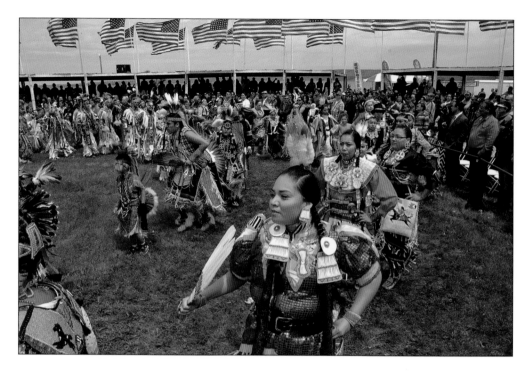

An Education Agenda. During his speech, President Obama bestowed accolades on the people of Standing Rock. He expressed hope that they would perpetuate their success and commitment to maintaining tribal cultures and languages by taking a vested interest in the education of their youth. Evidence of this commitment is easily seen in the ornate details of this ceremony. (Both, courtesy of Dennis J. Neumann, *United Tribes News*.)

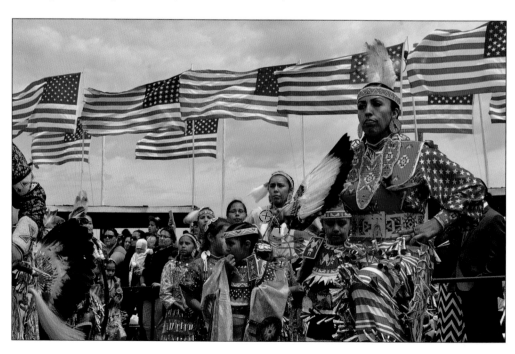

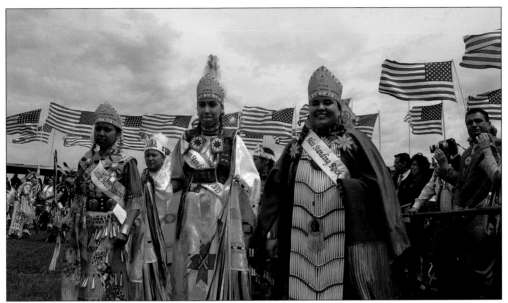

MISS STANDING ROCK. Former winners of Miss Standing Rock competitions wore their sashes to commemorate the day. Seen here are, from left to right, Little Miss Standing Rock, Miss Standing Rock 2013, and Miss Standing Rock. (Courtesy of Dennis J. Neumann, *United Tribes News*.)

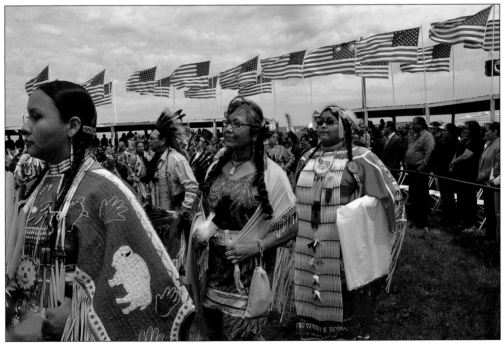

GRAND ENTRY. Jennifer Mellette (center) is from Wakpala. At left in the background is Frank Jamerson Jr., wearing a yellow beaded vest. He is from Wakpala, South Dakota. (Courtesy of Dennis J. Neumann, *United Tribes News*.)

Dr. Sarah Jumping Eagle and Chase Iron Eyes. Sarah Jumping Eagle and Chase Iron Eyes pose during the celebration. Jumping Eagle, a medical doctor, is from Cannonball. (Courtesy of Dennis J. Neumann, *United Tribes News*.)

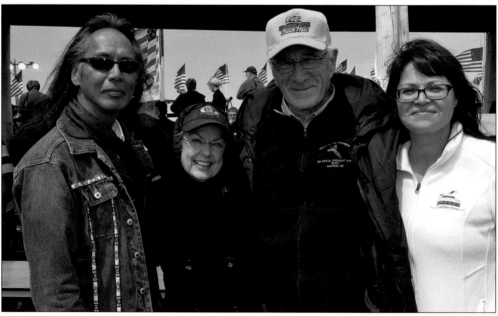

College Supporters. Ron His Horse Is Thunder (left) poses with benefactors of Sitting Bull College. At far right is Pamela Ternes, the public transportation director of Sitting Bull College. (Courtesy of Dennis J. Neumann, *United Tribes News*.)

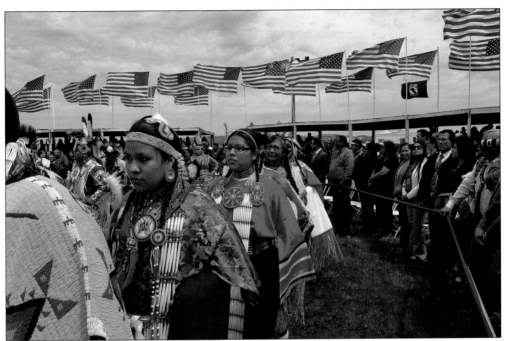

A Culture Revered. During his speech, President Obama quoted Sitting Bull: "Let's put our minds together to see what we can build for our children." Judging by the reverence paid during this ceremonious presidential visit and powwow, great strides have been made to build a community based on tradition and respect. Below, Ronnie Eagle Chasing is pictured with buffalo headdress and painted face. Viewing the dancers at center is Vernon Bruce Two Shields, in black hat. (Both, courtesy of Dennis J. Neumann, *United Tribes News*.)

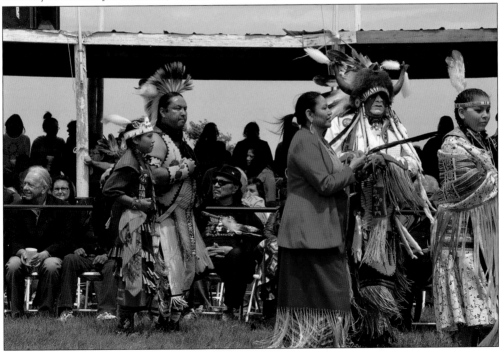

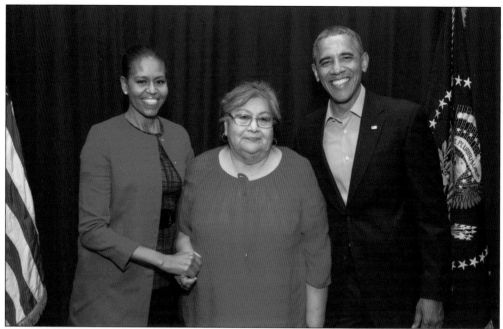

THE OBAMAS AND JAN TWO SHIELDS. During the Obamas' visit to Cannonball, North Dakota, tribal member Jan Two Shields stated that she was humbled and honored to meet the president and First Lady. Two Shields, a veteran, recognized this as a most significant and historic visit, as did the community of Cannonball. (Courtesy of Jeanette Two Shields.)

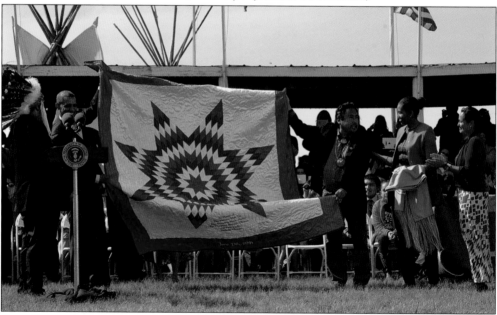

STAR QUILT. A star quilt is being presented to President Obama and First Lady Michelle Obama. From left to right are chairman Dave Archambault II, Pres. Barack Obama, Standing Rock Sioux Tribal Councilman Frank White Bull, Michelle Obama, and Nicole Archambault. Michelle Obama holds a dance shawl with the Standing Rock Sioux tribal seal, which was presented to her. (Courtesy of Dennis J. Neumann, *United Tribes News*.)

BIBLIOGRAPHY

Corson County History. Corson County history book staff.

Densmore, Frances. *Teton Sioux Music and Dance.* Lincoln, NE: University of Nebraska Press, 1918.

Dickson, Ephriam D. III. *The Sitting Bull Surrender Census.* South Dakota State Historical Society, 2011.

Greene, Candace S. and Russell Thornton. *The Year the Stars Fell.* Lincoln, NE: University of Nebraska Press, 2007.

Greene, Jerome. *American Carnage: Wounded Knee, 1890.* Norman, OK: University of Oklahoma Press, 2014.

Hinton, May E. *South of the Cannonball.* Grand Forks, ND: Washburn Printing Center.

Larson, Robert W. *Gall: Lakota War Chief.* Norman, OK: University of Oklahoma Press, 2009.

Sioux County History. Selfridge, ND: Sioux County history book staff.

Sitting Bull College. Fort Yates, ND.

Sprague, Donovin Arleigh. *Cheyenne River Sioux.* Charleston, SC: Arcadia Publishing, 2003.

————. *Pine Ridge Reservation.* Charleston, SC: Arcadia Publishing, 2004.

————. *Rosebud Sioux.* Charleston, SC: Arcadia Publishing, 2005.

————. *Standing Rock Sioux.* Charleston, SC: Arcadia Publishing, 2004.

————. *Ziebach County 1910–2010.* Charleston, SC: Arcadia Publishing, 2010.

Standing Rock tourism web site. www.standingrocktourism.com

Standing Rock Tribal Historic Preservation Office. Fort Yates, ND.

Standing Rock web site. www.standingrock.org

Timber Lake and Area Centennial History 1910–2010. Timber Lake and Area Historical Society. Aberdeen, SD: Midstates Quality Quick Print, 2009.

United Tribes Technical College. Bismarck, ND.

Waggoner, Josephine and Emily Levine, ed. *Witness—A Hunkpapha Historian's Strong-Heart Song of the Lakotas.* Lincoln, NE: University of Nebraska Press, 2013.

INDEX

Agard, Aljoe, 29
Alkire, Helen, 80
American Horse Jr., Antoine, 65
American Horse, Rose, 65
American Horse, Verdelia White Buffalo, 65, 66
American Horse, Yamni, 65, 66
Amiotte, Arthur, 44
Archambault, Charlotte, 73
Archambault II, Dave, 82, 83
Archambault, Nicole Thunder Hawk, 82, 86
Archambault, Ronald, 60, 74
Archambault, Wyman, 55, 73
Bahm, Ken, 61
Baird, Phil, 63
Barker, John, 61
Barth, Debbie, 64
Bear Catches, Brittany, 68
Bear Catches, Deanne, 68, 75
Bear Ribs, Randy, 85
Bearshield, Reynolds, 52
Becker, Pat, 61
Beheler, Billi Jo, 50
Birdsall, Mrs., 65
Bobtail Bear, Anthony, 81
Bobtail Bear, Tony Sr., 55
Bookless, Mrs., 65
Brown Otter, Brittany, 69
Buckner, Anna LaMonte, 54
Bullhead, Earl, 48, 56
Bullhead, Mrs., 65
Cadotte, Mrs., 65
Cadotte, Dorothy, 43, 45
Cadotte, Roger, 43
Cadotte, Scholastica Mad Bear, 45
Cadotte, Verna, 43, 45, 47, 49
Claymore, Gus, 55
Clinton, Hillary, 58
Cramer, Kevin, 87
Davis, Scott, 77, 87
DeCory, Dawson, 44
DeCory, Jace, 43, 49
DeCory, Junior, 44
DeCory, Sam, 44
Defender-Wilson, Mary Louise, 44, 54

Deloria Jr., Vine, 42, 49
Denver, John, 43
Disrud, Jim, 60, 61
Dunn, Joe, 51
Eagle, Jenny Gayton, 76
Eagle, Ted, 76
Eagle Chasing, Ronnie, 84, 91
Eagleman, Oliver, 59
Eaglestaff, Bob, 61
Eaglestaff, Bill, 60, 62
Eaglestaff, Darrell, 55, 59, 60
Edwards, Marge, 75
Finley, Kevin, 63
Flying Bye Benoist, Cordelia, 52
Flying Bye, Joe, 52, 75
Flying Bye, Leona, 52
Flying Bye, Moses, 52
Flying Earth, Duta, 66
Flying Earth, May, 66
Flying Earth, Winona, 66
Fool Bear, Archie, 56
Fools Crow, Frank, 43
Fools Crow, Kate Pawnee Leggins, 43
Fox, Spencer, 50
Galluzzi, Walter, 74
Gillette, Jodi Archambault, 67
Gipp, Albert, 55
Gipp, David M., 67, 87
Gipp, Gerald, 67
Gipp, Lelewis, 85
Gipp, Robert, 67, 74
Gipp Jr., Albert, 59
Goodhouse, Cedric, 55
Goodhouse, Mr., 86
Goodhouse, Sissy Buckley, 55
Grey Bear, Jerry, 60
Goudreaux, Roger, 60, 61
Grindstone, Amy, 52
Grindstone (Shoots Walking), Ella, 52
Grindstone, Romona, 52
Grindstone, Stella, 52
Gross, Ron, 61
Hack, Richard, 60
Halfe, Benny, 84
Hall, Faith, 86
Hawk, Brad, 85

Hayes, Larry, 74
Heck, Kevyn, 55
Helper Sr., William, 46
His Horse Is Thunder, Ron, 90
Hoeven, John, 87
Hornbeck, Billi, 87
Hotchkiss, Arlene Jordan, 47
Ireland, Cameron, 86
Iron Cloud, Del, 50
Iron Eyes, Chase, 90
Iron Shield, Harold, 75
Jamerson, Theodore "Tiny Bud," 73
Jamerson Jr., Frank, 84, 89, 91
Jochium, Ernest, 61
Johnson, Tim, 49
Jumping Eagle, Sarah, 90
Kary, Cheryl, 59
Katus, Tom, 49
Kaufman, Hattie, 72
Keeps Eagle, George, 58, 80
Keeps Eagle, Kyle, 58
Keeps Eagle, Marilyn, 58, 80
Keeps Eagle, Mitchell, 58
Keeps Eagle, Wade, 58
Kennedy, Robert F., 80
Kidder, Felix, 65
Kidder, Mrs., 65
Kills Crow, Arnold, 59, 74
Kills Pretty Enemy Jr., Mike, 75
Kloss, Carole, 54
Lafferty, Aaron, 75
Laubach, Sherman, 55, 60
Lawrence, Russell, 74
LeBeau, Marcella, 87
Lentz, Cuny, 45
Lentz, Gusey, 43
Libby, Aaron, 60
Libby, Kerry, 50, 53
Linquist, Cynthia, 72
Little Eagle, Avis, 51
Little Owl, Christine, 48
Little Owl, Lorraine, 48
Loans Arrow, Zona, 48, 51
Locke family, 66
Locke, Kevin, 66
Locke, Kimimila, 66
Locke, Patricia, 66

Luckens, Bill, 61
Luckens, Fred, 61
Luger, Joe, 64
Martin, Therese, 45, 46, 47
Mason, Jessica, 45
McCloud, Richard, 51
McDonald, Russell, 51
McKnight, Nia, 66
McKnight, Sheridan, 66
McLaughlin, Jesse, 51
Mellette, Jennifer, 89
Milligan, Frances, 66
Mills, Billy, 63, 69
Mills, Pat, 69
Murphy, Charles, 71
Netterville, Claude, 61
Neumann, Dennis J., 75
Obama, Michelle, 81, 82, 86, 92
Obama, Barack, 51, 81, 82, 83,
 86, 88, 91
Old Coyote, Heaven Rose, 64
Old Coyote, Mikaylee, 64
One Feather, Frank, 60, 61
One Feather, Gerald, 49
Pleets, Wilbur, 74, 77
Power, Susan, 70
Pretends Eagle, Shaydee, 69
Pudwill, Dylan, 52
Pudwill, Rhiana, 52
Ramey-Neumann, Joanie M.,
 48, 63
Red Tomahawk, Verle, 55, 59
Ressler, Koreen, 72
Romero, Nick, 68
Sabla, Kiana, 66
Sainte-Marie, Buffy, 45
Sandlin, Stephanie Herseth,
 46
Schaeffer, Ed, 77
Schaf, D., 61
Schaf, W., 61
Schimmel, Shoni, 64
Shoots the Enemy, Charles, 68
Silk, Duane, 85
Skye, Harriet, 78
Spiegelman, Sheldon, 60
Sprague, Ava, 52
Sprague, Ella, 50, 52

Sprague, Nels, 52
Sprague, Rosie (Two Shields),
 50, 68
Swisher, Clark Jr., 55, 60
Taken Alive, Cheryl, 73
Taken Alive, Imogene Noreen,
 47
Taken Alive, Jesse "Jay," 55,
 60, 73
Taken Alive, Virgil, 60, 61
Teachout, Margaret Halsey,
 58, 67
Ternes, Pamela, 90
Thomas, Mark, 61
Three Legs, Vaughan, 56
Thunderhawk Jr., Wallace
 "Butch," 42
Trader, 62
Two Bears, Cody, 51
Two Bears, Sharon, 72
Two Shields, Jan, 51, 60
Two Shields, Samson, 76
Two Shields, Vernon Bruce, 91
Vermillion, Laurel, 72
Vermillion, Sylvester, 74
Village Center, Leonard, 74
Walks, Ken, 55
Weigel, G., 61
White, Randy, 51
White Bull, Frank, 92
White Eagle, Melvin, 53
Yellow Fat, Terry, 56
Yellow Hammer, Joe, 74
Yellow Hammer, Walter, 74
Young, Phyllis, 70

DISCOVER THOUSANDS OF LOCAL HISTORY BOOKS FEATURING MILLIONS OF VINTAGE IMAGES

Arcadia Publishing, the leading local history publisher in the United States, is committed to making history accessible and meaningful through publishing books that celebrate and preserve the heritage of America's people and places.

Find more books like this at
www.arcadiapublishing.com

Search for your hometown history, your old stomping grounds, and even your favorite sports team.

Consistent with our mission to preserve history on a local level, this book was printed in South Carolina on American-made paper and manufactured entirely in the United States. Products carrying the accredited Forest Stewardship Council (FSC) label are printed on 100 percent FSC-certified paper.

MADE IN THE USA